IMAGES
of America

PALMETTO WOMEN

IMAGES FROM THE
WINTHROP UNIVERSITY ARCHIVES

Dear Nattie,
This makes me want to put
'blue food dye' into some
college fountain!
Love you much,
— John

IMAGES
of America

PALMETTO
WOMEN

IMAGES FROM THE
WINTHROP UNIVERSITY ARCHIVES

Ron Chepesiuk
and Gina Price White

ARCADIA
PUBLISHING

Published by Arcadia Publishing
Charleston, South Carolina

Printed in the United States of America

Library of Congress Catalog Card Number: 99-60275

For all general information contact Arcadia Publishing at:
Telephone 843-853-2070
Fax 843-853-0044
E-mail sales@arcadiapublishing.com
For customer service and orders:
Toll-Free 1-888-313-2665

Visit us on the Internet at www.arcadiapublishing.com

*To the memory of Dr. Arnold Shankman,
scholar, educator, and friend.*

CONTENTS

INTRODUCTION

Since South Carolina's beginning, women have actively influenced the state's political, social, and economic development. Indeed, the record has been remarkable. Did you know, for instance, that South Carolina women were instrumental in securing state appropriations for public libraries, working for the regulation of child labor, establishing governmental standards for the enrichment of cereal and flour, and lobbying for legislation to establish compulsory school attendance laws?

These important activities and accomplishments are documented in the Winthrop University Archives, which since 1962 has collected the records of the university, state women's organizations, societies and clubs, and the papers of women who have made contributions to South Carolina's history. The archive holdings document the activities of women in several subject areas, including education, religion, politics, sports, business, the arts and sciences, and community service. The department also preserves the history of Winthrop University, which from its founding in 1886 until 1974, the year it became coeducational, was one of the country's largest women's colleges. The documentation encompasses diaries, scrapbooks, reports, letters, photographs, newsletters, and other significant material.

This book draws on that documentation and the resources of the Winthrop University Archives and its Women's History Collection to provide a visual record of aspects of the legacy of South Carolina women in the state and nation's development. The Winthrop Archivists hope that this pictorial album will give readers a better understanding and appreciation of women's history.

In no way is this book intended to be all inclusive in scope. It draws mainly on the resources of the Winthrop University Archives, and so many women who have accomplished much and rendered outstanding service to South Carolina could not be included. They deserve recognition, and hopefully, other books like this one will be compiled and written.

The Winthrop Archives would like to thank several individuals and institutions that helped make this book possible, including Glinda Price Coleman, Dr. Edward Lee, the Converse College Archives, the South Carolina Commission on Women, the Public Relations Office at Columbia College, the Women's Studies Center at the University of South Carolina, the *Herald* of Rock Hill, Mary DeYoung, and the many donors who have contributed material to the Winthrop Archives.

We hope readers enjoy our effort and help the Winthrop Archives and other South Carolina repositories continue documenting South Carolina women's history.

One

HOME

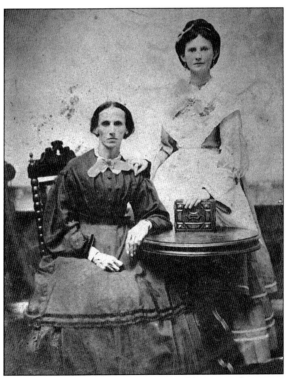

When photography first became a means to obtain a likeness of a person, photographs were printed on glass and were known as daguerreotypes. This expensive process was generally open only to the rich. In the 1850s, however, the collodion process was developed, and it introduced the ambrotype and the tintype. These much less expensive processes brought photography to the common folk. This tintype features two unidentified, middle-class women c. 1860. Notice the tiered skirts and dropped-shoulder sleeves. The women are not smiling because of the long exposure time of the film, and it's probable that most people at that time had bad teeth. Smiling is a 20th-century innovation.

December 14th 1862

[handwritten journal entry, largely illegible cursive]

December 22d 1862

[handwritten journal entry, largely illegible cursive]

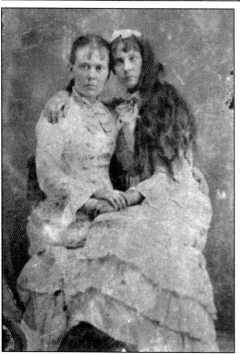

In 1861, David Harris left his 100-acre farm that was located 8 miles southeast of Spartanburg and marched off to defend the Confederacy. He left his wife, Emily Liles Harris, with seven children and ten slaves. These entries are from one of the journals that the family kept. Mrs Harris kept the journal in her husband's absence. It is a fascinating record of civilian life during the War Between the States.

This tintype of two unidentified women who lived near Batesburg is from the early 1870s. They are probably sisters, dressed in their Sunday best, for a portrait for their parents.

With the rising popularity of photography, most towns could boast of at least one studio, quite often more. Seen in this 1877 photograph is Mary McCarter at the studio of John R. Schorb & Son in Yorkville.

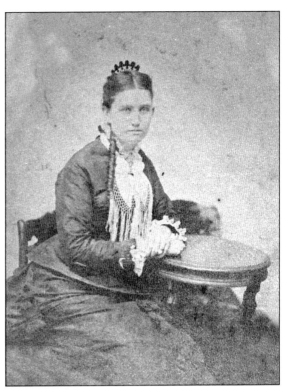

Pictured is an unidentified woman in an 1880s studio portrait. Notice the painted backdrop.

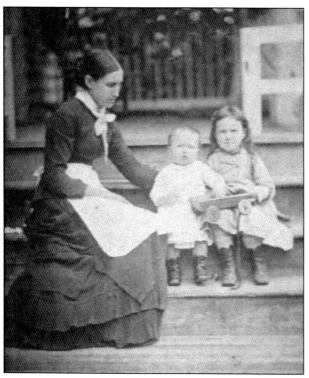

In the 19th century, most of
the women in South Carolina
worked inside the home. This
usually included taking care of
children. These two c. 1870s
photographs are views of
mothers and their children.

Nancy Dunlap Knox was born in Kershaw County. In 1846, she married James Nesbit Knox, a farmer in Chester County. She and her husband raised three sons and one daughter. One of her sons became a doctor; another became an educator and the first superintendent of education in Chester County. Many of her descendants still live in Chester County.

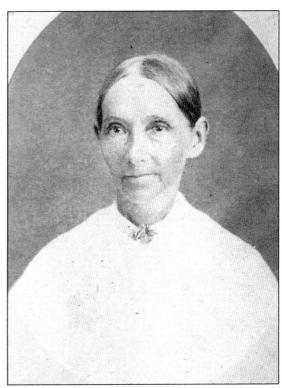

Pictured in this c. 1890s view is an unidentified young woman from Columbia. She may have been a Winthrop student.

13

Mai Rutledge Smith Johnson was born on January 3, 1878, and died on her 100th birthday. She grew up in Charleston.

In 1902, Mai Rutledge Smith became the wife of David Bancroft Johnson, founder and first president of Winthrop College (now University). She graduated from the school in 1898 and began working as a stenographer there. Legend has it that Johnson dictated his marriage proposal to her, but she never would deny or confirm the story. She raised three children on the campus. After her husband's death in 1928, Mai continued working as an assistant librarian until the age of 91. This is Mai on the steps of her childhood home.

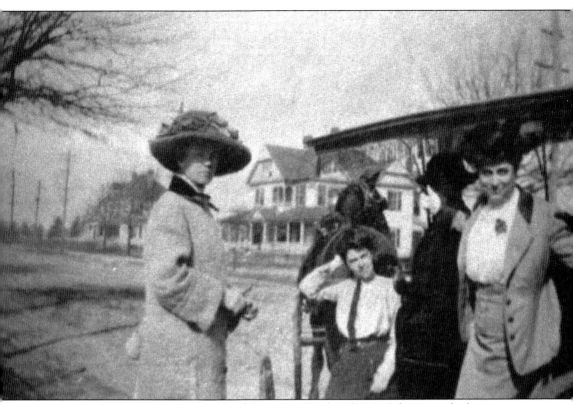

Seen in this 1898 view taken at Oakland Avenue in Rock Hill, Mai Johnson and others prepare to depart in a surrey.

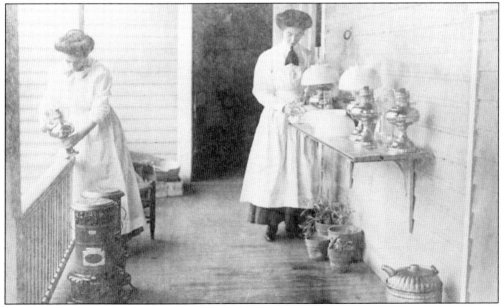

In 1909, Winthrop established a practice home management house, one of the first of its kind in the United States. Groups of students would live in the house for part of a term to gain practical experience in the home. Here, students are cleaning lamps, c. 1910.

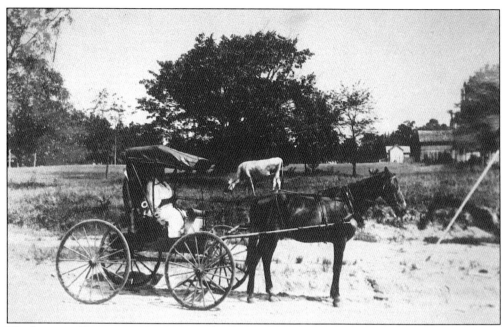

The horse and buggy was the main mode of transportation in rural South Carolina at the turn of the century.

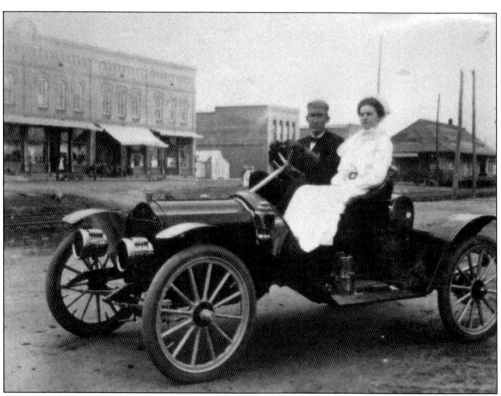

Less than 20 years into the 20th century, the automobile began to take over the transportation scene. Women were not encouraged to drive.

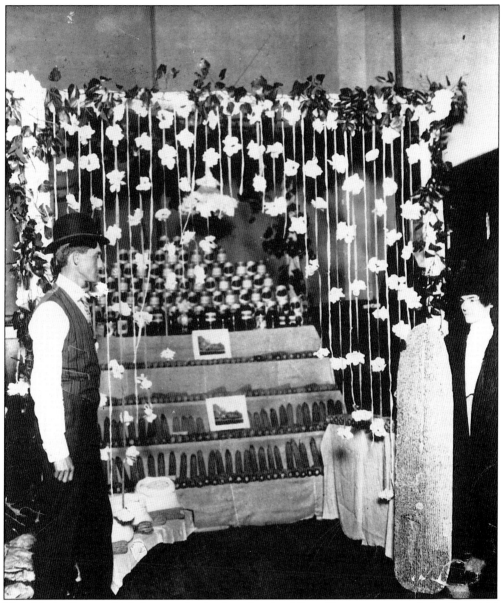

Miss Marie Cromer (right), a rural schoolteacher in Aiken County, sponsored the first girls' tomato club in 1910, after hearing Dr. Seaman A. Knapp speak at a Rural School Improvement Association meeting. Mr. C.H. Seigler (left) was the Aiken County School superintendent at the time and the sponsor of the boys' corn club. Miss Cromer's and Mr. Seigler's clubs put up a joint exhibit at the Corn Show in Columbia on December 8, 1910. There were 47 girls in the first club, and the movement grew statewide. Miss Cromer and Mr. Seigler were later married.

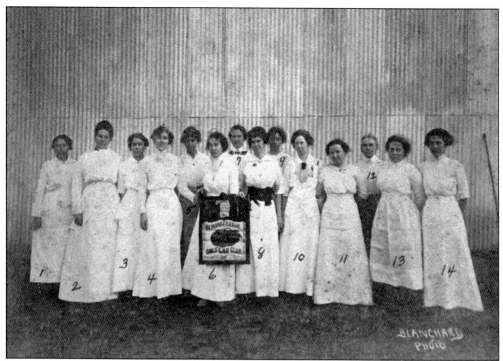

Seen in this c. 1910 view are the leaders of the Demonstrator Girls' C&P Clubs. A number of these women went on to make quite a name for themselves. Those identified in this photograph are as follows: Mrs. Dora D. "Mother" Walker (3); Mrs. Elizabeth Dickson Hutto (4); Mrs. Edith Parrott Savely, state agent (6); Miss Minnie Garrison (7); Miss Mary Eva Hite (8); Mrs. Kate Simpson Taylor (10); Mrs. Mary Lemmon McCoy (11); and Miss Wil Lou Gray (13).

Clubs were segregated in the early days of the Home Demonstration Movement. This is a canning and needlework exhibit put on by the York County "Colored" Club in 1921.

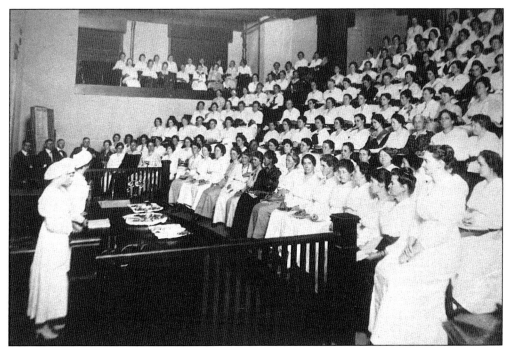

Winthrop College was the headquarters of the Home Demonstration (or Extension) Movement until it was moved to Clemson in 1959. Every year, the college would host short courses for members of Home Demonstration Clubs all across the state. This nutrition class was photographed in 1918.

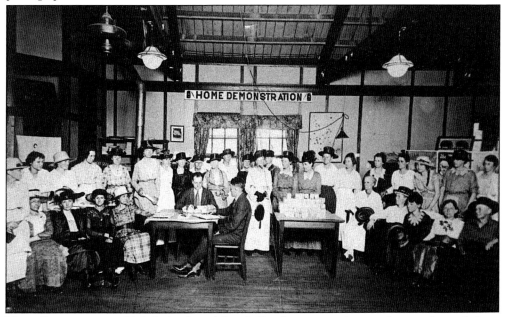

Home Demonstration Clubs helped rural South Carolina women become better educated about how to maintain their farms and nurture their families. The clubs were also outlets for showing off a woman's skill at a particular task. This is the third judging of a butter-making contest in Spartanburg County, which was held in July of 1920.

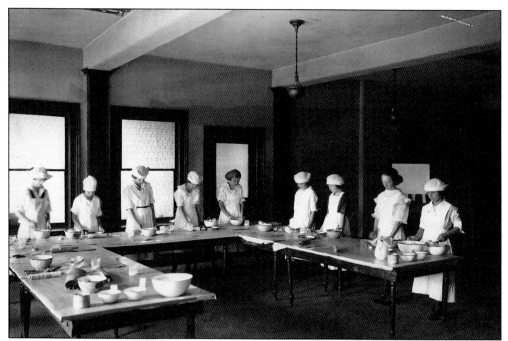

The girls' 4-H Club often had biscuit-making contests. The photograph above is a view of the Piedmont District Contest in 1921, and the image below shows the York County Contest held the same year.

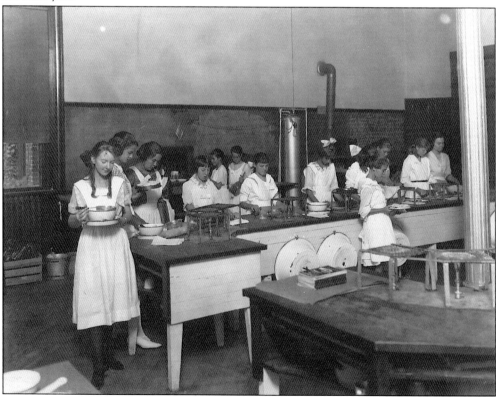

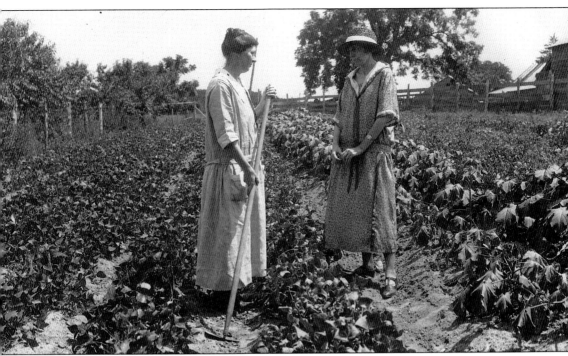

A home demonstration agent visits a club member in Spartanburg County *c.* 1920s.

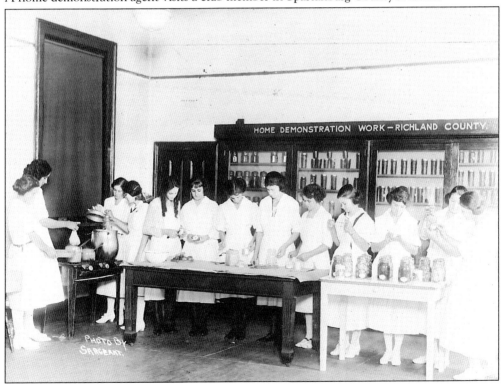

This scene is of the State Canning Contest held in Columbia in 1922. Six county teams were competing.

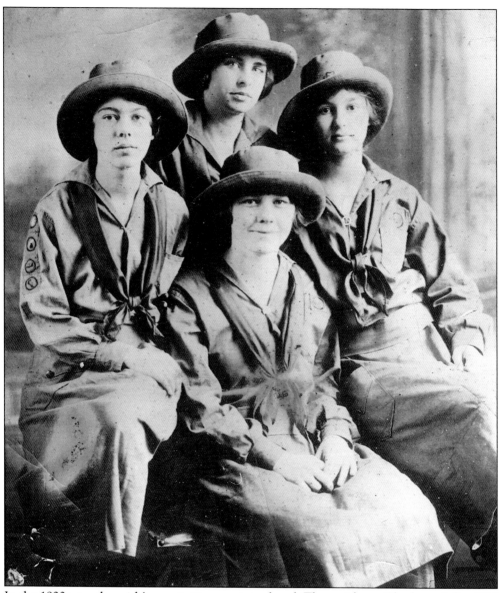

In the 1920s, another girls' organization was introduced. These girls are Charleston's first Girl Scouts. The girl on the far left is identified as Rosalie McCabe. She organized Troop 1 at Ashley Hall in 1923. The photograph is dated November 23, 1923.

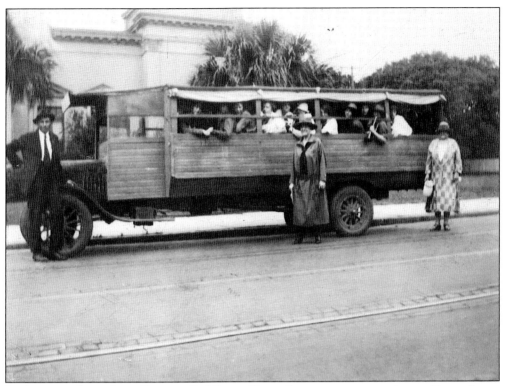

In the view above, Low Country Girl Scout Council scouts are seen going to Camp Agnes Ann in the 1920s. Below, girl scouts are seen participating in the raising of the flag at the camp at Meggett.

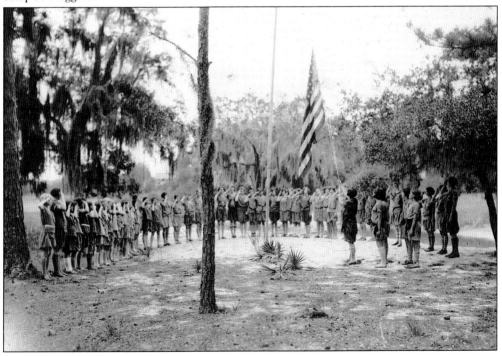

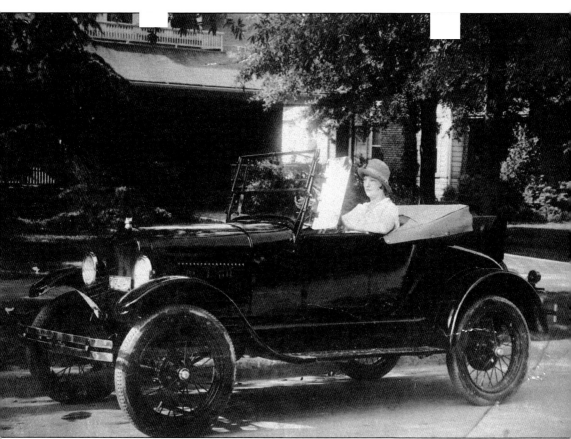

By the mid to late 1920s, women driving automobiles became a more frequent sight on the state's streets and highways. This is Louise Thomas in her red Ford on a street in Rock Hill.

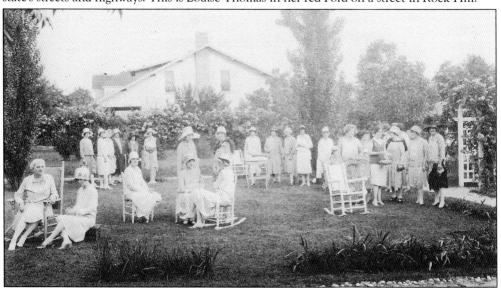

Clubs became popular for women in the first quarter of the 20th century. Here, the Rock Hill Music Club has a garden party in 1926.

The graduating class of 1928 from St. Peter's High School in Columbia seems to have only one male student. The only identified person is Mary Agnes Bond. Seen here on the top row, third from the left, she became an employee of the I.R.S.

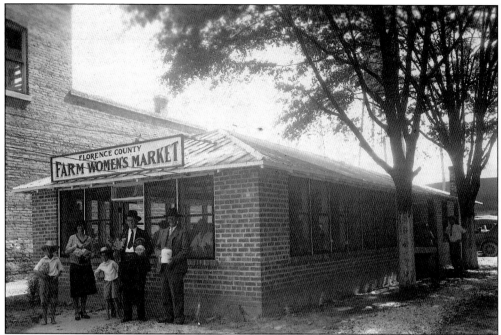

Home demonstration agents introduced to farm women a way of adding to their income by selling their surplus produce in club-sponsored markets. They would sell vegetables, fruits, butter, eggs, preserves, and anything else that was a product of their handiwork. Here, customers are seen leaving the Florence County Farm Women's Market in the early 1930s.

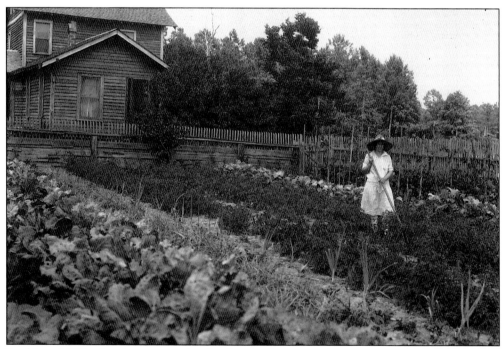

In this c. 1930s view is an example of a fine garden grown by a woman who sells her extra produce at a county club market.

Many farm women used the extra money from club market sales to buy items they might not otherwise be able to afford. Here, Mrs. Rembert stands by a car she bought with the earnings from her club market sales in Florence County, c. 1930s.

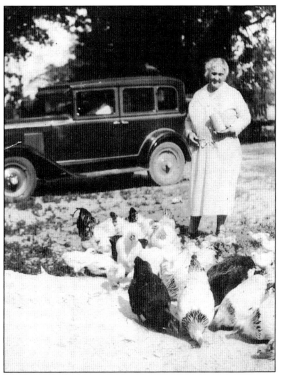

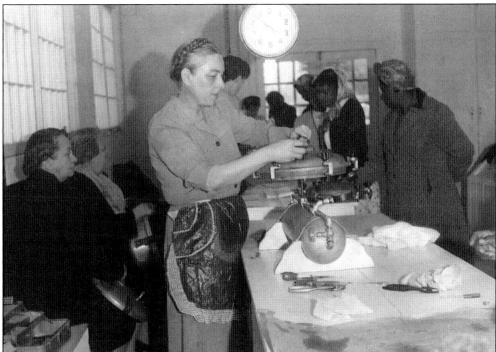

Some of the club market buildings were also used for demonstrations. Eva McGee, the Colleton County Home Demonstration agent, is seen here conducting a pressure cooker clinic in the 1930s.

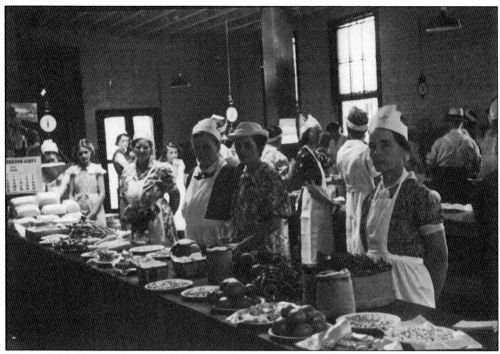

This is the interior of the Rock Hill Home Demonstration Market in June 1938.

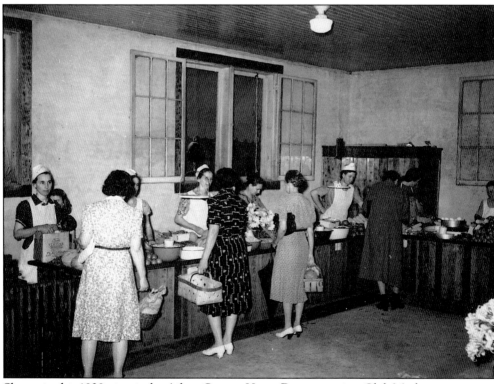

Shown in this 1939 view is the Aiken County Home Demonstration Club Market.

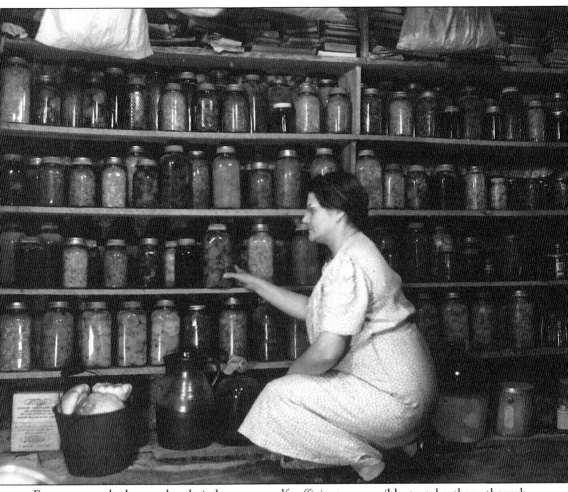

Farm women had to make their homes as self-sufficient as possible to take them through the lean times. Mrs. Will Byrd of Kershaw County shows off her vast array of canned fruits and vegetables.

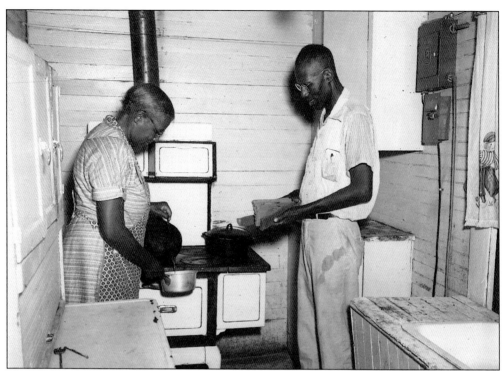

Remodeling projects were another way in which home demonstration clubs helped their members. The photograph above is a view of a kitchen in Darlington County before it was remodeled. Below is the same kitchen after the c. 1940s renovation.

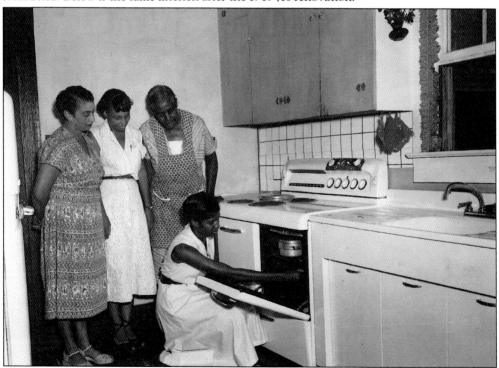

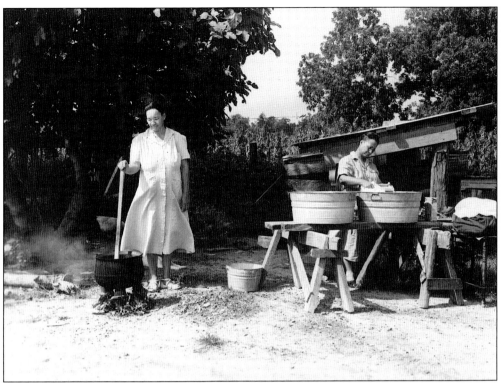

The extension service put out booklets to aid farm families who had no electricity or running water, and provided instructions on such things as how to keep perishables cool without refrigeration or an icebox, and how to put a sink in the kitchen. Above, in this c. 1939 photograph, is a demonstration of how many rural women had to wash their laundry before they had running water. Seen to the right is Mrs. Bell of Lee County at her new sink in July 1939.

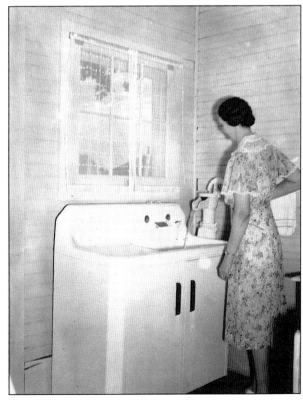

Mrs. C.N. Norton of Kershaw County, Mt. Pisgah community, shows off the new wood range and built-in cabinets in her kitchen in 1940

Needlework was also a part of the home demonstration clubs. This unidentified woman from White Oak (Fairfield County) works on her sewing in 1939.

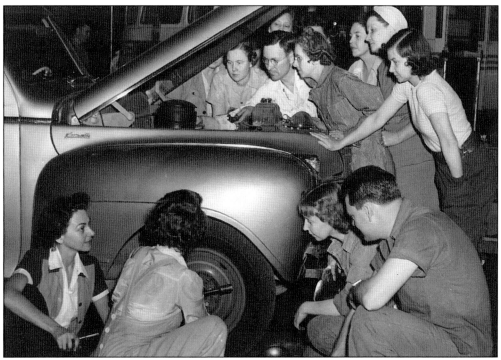

Many women left their homes during World War II in order to help with the war effort. These Red Cross workers are taking a motor corps course in Rock Hill.

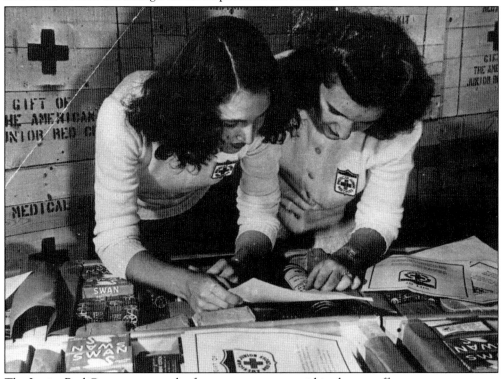

The Junior Red Cross was an outlet for young women to aid in the war effort.

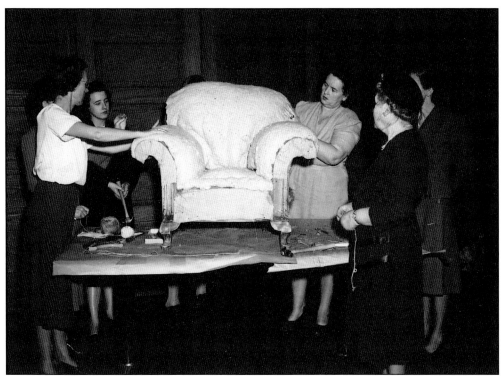

In the late 1940s, the extension service offered an upholstery workshop in Greenville County.

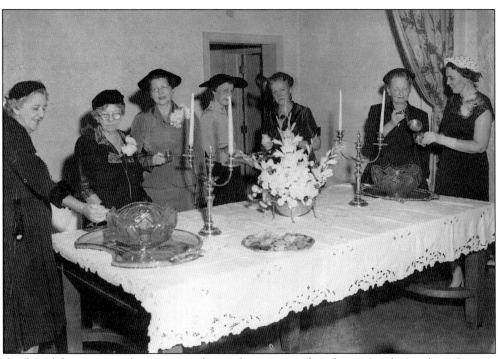

Garden clubs were—and continue to be—a favorite social outlet in South Carolina. Seen in this 1952 view is the 25th Anniversary Tea Party of the Sumter Garden Club.

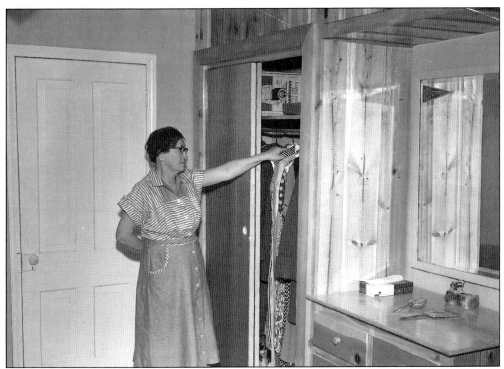

Mrs. W.C. Prince, a member of the Diamond Hill Home Demonstration Club in Abbeville County, shows off her new closet in 1956.

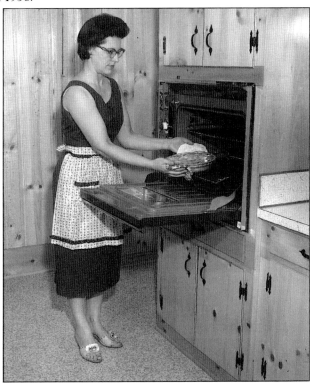

Dorothy Coleman of Saluda County bakes in her remodeled kitchen in 1959.

In this 1950s photograph, taken during Farm and Home Week, Ruby Craven gives a presentation on housing issues.

Pictured here are the officers of the State Council of Farm Women in 1952. The women, from left to right, are as follows: (front row) Mrs. H.M. McLaurin of Sumter County, 1st vice president; and Mrs. Gordon Blackwell of Saluda, president; (back row) Mrs. M.H. Lineberger of Catawba, 2nd vice president; Mrs. M.H. Lawton of Beaufort, central district director; and Mrs. Clarkson Stevenson of Chester, treasurer.

Two

EDUCATION

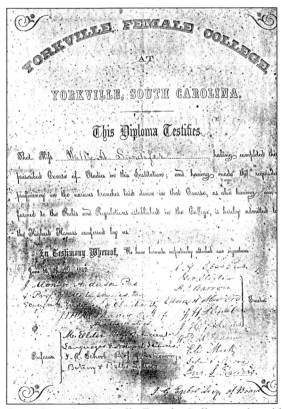

This faded, 1859 diploma from the Yorkville Female College is the oldest education-related document in the Winthrop Archives. The recipient of the diploma was Sallie A. Sandifier.

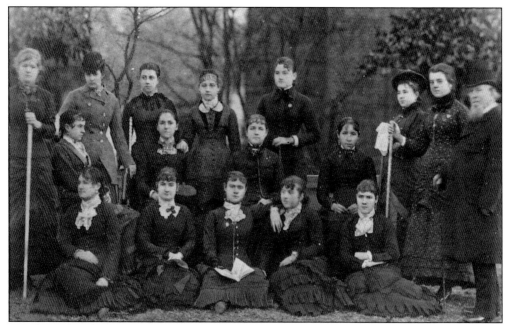

Members of Columbia College's Class of 1881 pose on the lawn with President T.L. Jones (far right). Columbia College was founded on December 21, 1854, as the Columbia Female College, when it received a charter from the South Carolina Methodist Conference in Columbia. The college opened in 1859 with 189 students.

A popular extracurricular activity for Columbia College students in the early 1900s was membership in the Chafing Dish Club.

Pictured are three of the 135 women enrolled in Columbia College in 1898. This was an era during which boarding students were not allowed to "accept attention from young gentlemen without written permission from their parents or guardian."

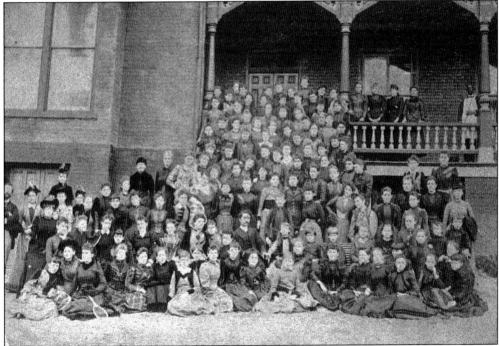

These students are posed in front of Converse College's original Main Hall. On March 22, 1889, 14 Spartanburg citizens met under the leadership of pioneer textile industrialist Dexter Edgar Converse to initiate the establishment of a woman's college. Converse College opened on October 1, 1890, with Benjamin F. Wilson (1890–1902) as president. On February 25, 1896, Converse was incorporated as an independent college. Today, Converse College is a thriving, women's liberal arts college.

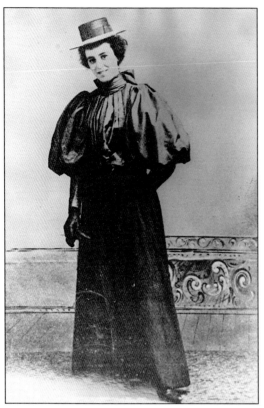

Winthrop University was founded in November 1886 in Columbia. The first year, 21 students enrolled but only 14 graduated. By 1890, Winthrop had outgrown its facilities in Columbia, forcing the college's Board of Trustees to find a new home in South Carolina. Cities that bid to become Winthrop's new home included Anderson, Chester, and Spartanburg. Rock Hill made the best offer, and Winthrop opened at its new location. Today, Winthrop University has more than 5,000 students.

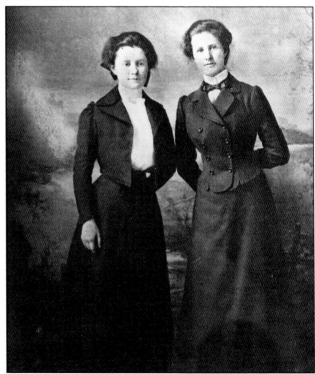

Winthrop students are seen in uniform in this late 1890s photograph. Students at the all-female college were required to wear uniforms until 1955.

This diploma was awarded to Gertrude May Hite on May 7, 1907.

Winthrop Normal and Industrial College

DINING HALL RULES

1. Students must assemble promptly during the ringing of the five minutes bell and remain in their places until the blessing is asked.
2. There must be perfect quiet during the blessing.
3. No loud talking, laughing, or boisterous conduct allowed in the dining-hall.
4. No food taken from the tables without permission from the housekeeper.
5. No dishes or silver shall be taken from the dining-hall.
6. No changing of seats in the dining-hall without permission from the proctor.
7. No young lady except the waitress must leave the table for food.
8. The waitress on duty must take the dishes off the trucks.
9. The waitress must remain in position and receive food from the trucks and deposit soiled dishes, and not run to meet trucks.
10. The waitress must be in the dining-hall five minutes before the last bell rings.
11. Students are not allowed in the kitchen except when waiting on tables.
12. No permission must be given to speak to students at other tables except through the house-keeper.
13. No young lady is allowed to leave dining-hall without permission from the one in charge of the table and then only to go to the Infirmary. The students at each table will be dismissed in a body.
14. All students who desire friends to dine with them will register at the Secretary's office one-half hour before the meal.
15. Hereafter, students will invite only parents or guardians to take meals with them in the dining-hall unless exception is made by special permission of the President.
16. No waiting for friends in corridors outside dining-hall doors.
17. Chairs are to be left in position at tables when not in use.

VIRGINIA T. BELL,
Housekeper.
Approved: D. B. JOHNSON,
President.

September, 1915.

In the early 20th century, the rules and regulations for Winthrop's female students were strict.

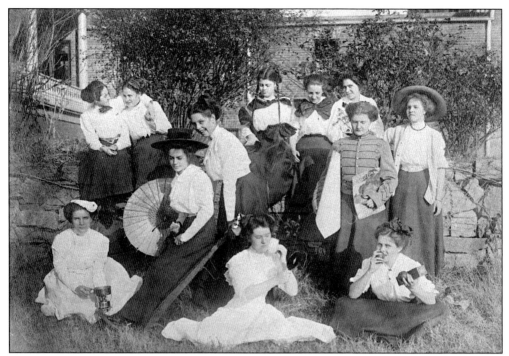

Shown here are Winthrop students in the early 1890s, when the university was still located in Columbia. Winthrop was moved to Rock Hill in 1895.

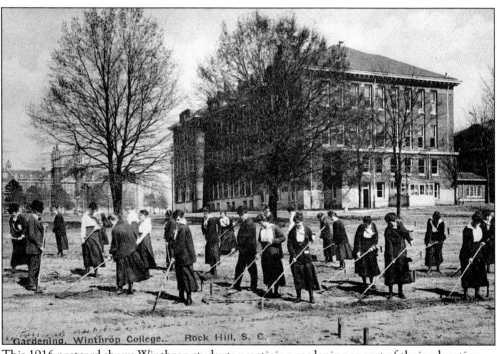

This 1916 postcard shows Winthrop students practicing gardening as part of their education.

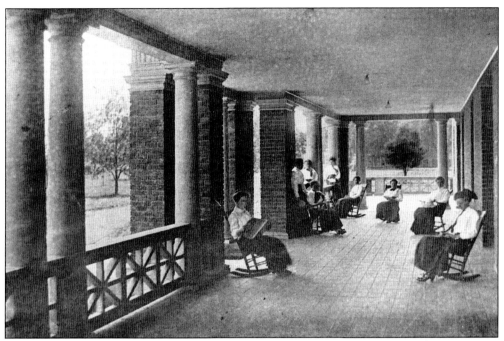

Winthrop University students relax on the porch of Bancroft Hall dormitory in this 1915 view.

Remember Baby Ray from *Child's World Primer?* The author is Sarah Withers, a Winthrop graduate and teacher. The university's Winthrop Training School building is named in her honor.

The South Carolina Daughters of the American Revolution (DAR) established the Tamassee Industrial School in 1914 for the benefit of the young girls of the mountains in the Oconee County region. While establishing such schools was an important objective of the DAR, South Carolina was the first to do so.

The CAROLINA PIONEER

Alumni Banquet July 8

Graduation July 9

New Series Volume III, No. 1 July 8, 1965 S. C. Opportunity School, West Columbia, S. C.

Miss Tolbert Retires

By RUBY KELLY

Miss Marguerite Tolbert, Assistant Director of the S. C. Opportunity School since 1958, will retire after fifty years' service to her state. She has been connected with The Opportunity School in some capacity since it was founded by Dr. Wil Lou Gray at Tamassee in Oconee County in 1921. Through the years she has served as teacher, Dean, or Consultant.

Miss Tolbert was born in Laurens, South Carolina, the daughter of Dora Gray and James Franklin Tolbert. She was graduated from the Laurens High School as Salutatorian; from Winthrop College with an A.B. Degree, Cum Laude; from Furman University with a Master's Degree in Adult Education. She did further study at Peabody College, Columbia University, University of South Carolina, and University of New York.

When asked why she chose teaching as a profession, she replied, "At that time there were not many doors open to women; jobs were limited; and the only respectable vocations for ladies included: teaching, nursing, secretarial work, and being a governess. Women were not allowed to vote until 1919; truly it was a man's world.

"The fact that I was graduated from Winthrop College encouraged me to teach. From a child I had said that I wanted to teach, and

enthusiastic about her work. She maintains there is no place in the South Carolina high schools, took world for lackadaisical, lukewarm individuals.

Her first teaching was in the Denmark High School where she taught Latin and Physics. Following this she taught in the public schools of South Carolina for 25 years: Chester, Darlington, Colum-

Summer School Figures Revealed

Despite the fire which destroyed West Dormitory a few days before school opened, the Summer Session has been able to accommodate almost the same size student body as last year, it was announced by W. T. Lander, Jr., school director.

Two hundred thirty-one people have enrolled in the various summer programs. Of this number one hundred and sixty-three are enrolled in the current regular summer session. Thirty-three counties are represented in the student body. Charleston with 28, Anderson with 21, and Richland with 18 lead the list.

It was pointed out that, after the fire, no new Summer School applications were processed unless they were actually on hand before the fire occurred on June 2.

As part of the summer program two special groups met on Campus June 6-11. Thirty-seven adults who were to take the S. C. High School Equivalency Test attended a concentrated schedule of classes, preparing for this test. Thirty-one seniors, current graduates from South Carolina high schools, took part in the Vocational Rehabilitation Evaluation Week here on campus during the same dates.

Commencement To Be July 9

By RONALD CLARK, BERT SELLERS, LESLIE JONES, AND LINDA CARRIGG

Opportunity School Graduation Exercises will be held Friday, July 9, 1965, in the Red Cross Auditorium.

Mr. W. T. Lander, Jr., Director, will preside.

We are greatly honored to have as our guest speaker, the Governor of South Carolina, Robert E. McNair. He will be introduced by the Honorable Harold D. Breazeale, Chairman of Education and Public Works Committee, member of the South Carolina House of Representatives.

Presentation of Certificates, Diplomas, and Bibles will be by Doctor M. R. Webb, Chairman of the Board of Trustees.

Listed below are the graduates.

1. Alley, Thaddeus 217 Hillman Dr., Anderson, S. C.
2. Andrews, Francis Shannon .. 108 Richard Ave., Darlington, S. C.
3. Atkinson, John L. 432 "M" Ave., Cayce, S. C.
4. Bland, Charles 3001 Lindsey St., Columbia, S. C.
5. Boykin, Charles Box 122 College St., Bishopville, S. C.
6. Bradshaw, Robert Henry ... 302 Rutledge Ave., Sumter, S. C.
7. Bridges, Larry Bruce Route 3, Easley, S. C.
8. Carraway, Ramona 1200 Henderson St., Columbia, S. C.
9. Case, Gloria Ann 13 Carrol St. West Columbia, S. C.
10. Ellerbe, Robert Greenwood, S. C.
11. Eubanks, Robert L. 3 City Ave., Lancaster, S. C.
12. Fogle, Harold Route 3, Box 541, Charleston, S. C.
13. Ford, Barbara Lea Route 1, Box 266, Lexington, S. C.
14. Francis, Ronald Steven 16 Argonne St., Charleston, S. C.
15. Gettys, Jack 1212 Brannon St., Greenwood, S. C.
16. Goff, Charles 1914 Moringlo Lane, Columbia, S. C.
17. Hadden, James Roy 24-2 Hendley Homes, Columbia, S. C.
18. LaFoy, Don 8409 Bohannon Dr., Dallas, Tex.
19. Lewis, Philip Box 471, Allendale, S. C.
20. Mack, Mrs. Margaret Gray 1533 Abbott Road, Cayce, S. C.
21. Moore, Mrs. Betty Ruth 142 S. Walker St., Columbia, S. C.
22. Osborne, Wiley Barton 219 Silver Bluff Rd., Aiken, S. C.
23. Holmes, Vera 1810 Hampton St., Georgetown, S. C.

Shown here is the July 6, 1965 issue of the *Carolina Pioneer*, the newsletter of the South Carolina Opportunity School. The school was founded in 1921 at Tamassee by Dr. Wil Lou Gray—one of 20th-century South Carolina's most distinguished citizens—as an institution to educate South Carolinians through adult education.

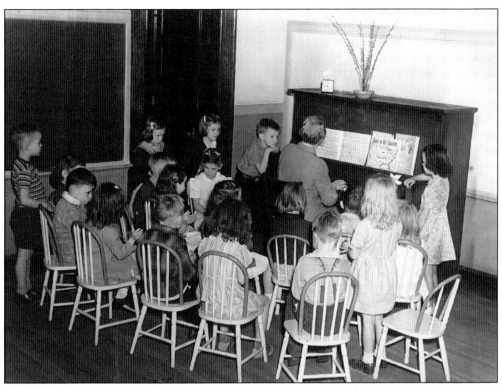

Here are two scenes from rural schools in South Carolina during the late 1930s and early 1940s.

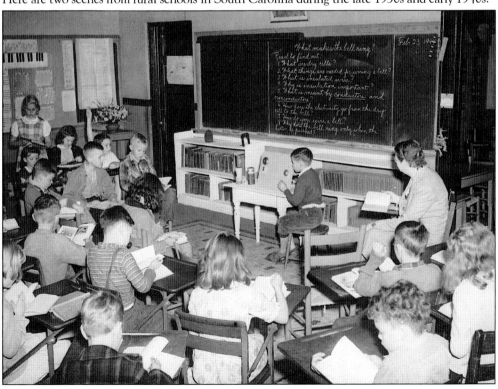

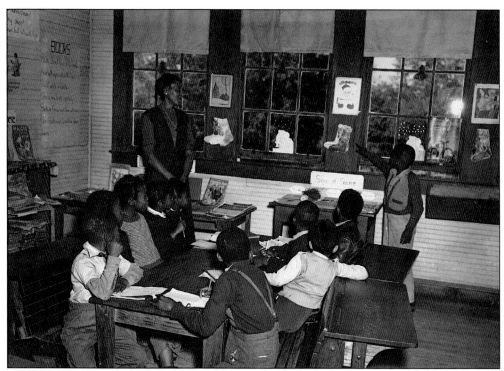

As teachers, women have played a seminal role in educating the state's citizens, even though at that time education was segregated.

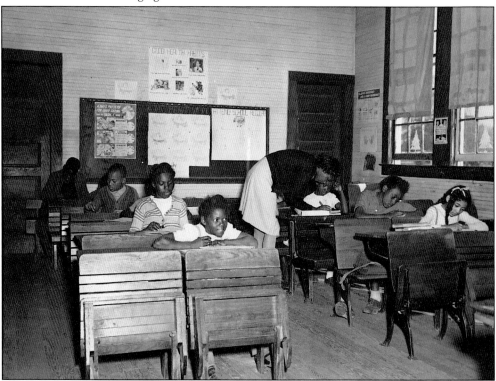

Mrs. Eleanor Roosevelt chats with students in the house of Winthrop University's president. She spoke at Winthrop on April 27, 1940.

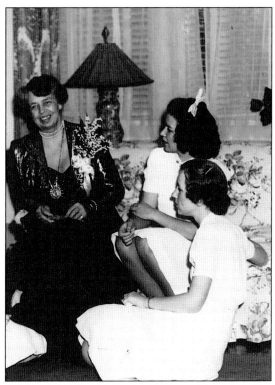

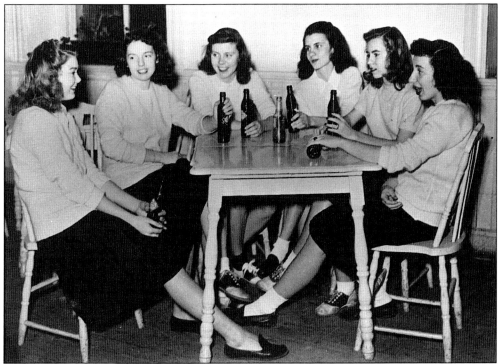

In this classic bobby-soxer scene from the 1940s, Winthrop students enjoy a soft drink at the canteen.

Pictured is Jean Carothers, the queen of the 1949 May Day celebration at Winthrop College, along with Bette King, the maid of honor. This Winthrop tradition began in 1925. On the first Saturday in May, hundreds of Winthrop parents, alumni, students, and townspeople filled the brick tiers of the amphitheater. The May Court consisted of 16 handmaidens, four from each class.

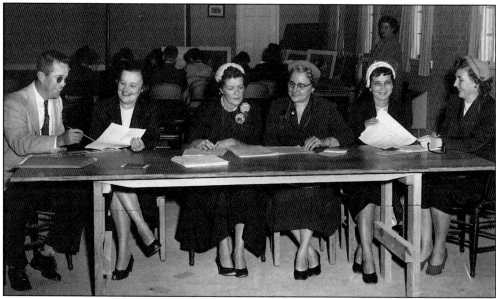

Shown here in 1949, officers of the Schneider School PTA meet to discuss educational matters. Founded in 1897, the PTA is made up of parents, teachers, students, principals, administrators, and others interested in uniting the force of home, school, and community on behalf of children and youth. Women have played a vital role in the PTA's growth and development.

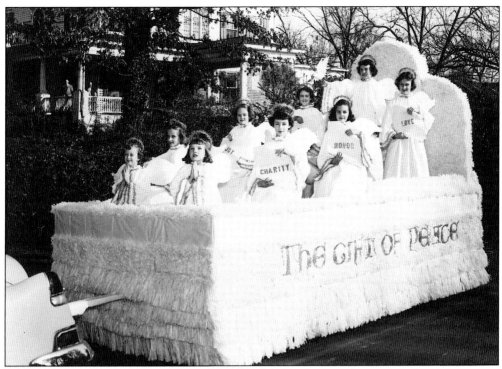

In 1954, young girls from Boundary Street School, located in Newberry, played angels.

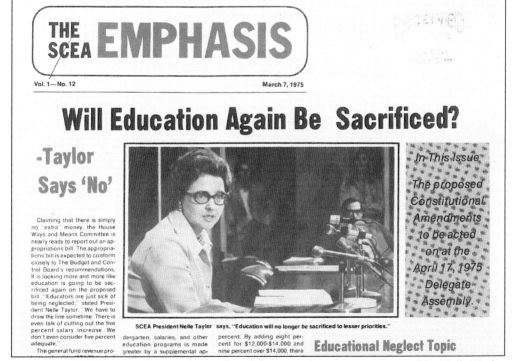

THE SCEA EMPHASIS

Vol. 1— No. 12 March 7, 1975

Will Education Again Be Sacrificed?

-Taylor Says 'No'

Claiming that there is simply no "extra" money, the House Ways and Means Committee is nearly ready to report out an appropriations bill. The appropriations bill is expected to conform closely to The Budget and Control Board's recommendations. It is looking more and more like education is going to be sacrificed again on the proposed bill. "Educators are just sick of being neglected," stated President Nelle Taylor. "We have to draw the line sometime. There is even talk of cutting out the five percent salary increase. We don't even consider five percent adequate."

The general fund revenue pro-

SCEA President Nelle Taylor says, "Education will no longer be sacrificed to lesser priorities."

dergarten, salaries, and other education programs is made greater by a supplemental ap-

percent. By adding eight percent for $12,000-$14,000 and nine percent over $14,000, there

In This Issue

The proposed Constitutional Amendments to be acted on at the April 17, 1975 Delegate Assembly.

Educational Neglect Topic

As high level officers in the South Carolina Education Association, women like Nelle Taylor have played a prominent role in promoting the best interests of education in the state.

Shown here are campus scenes at Winthrop University in the 1950s.

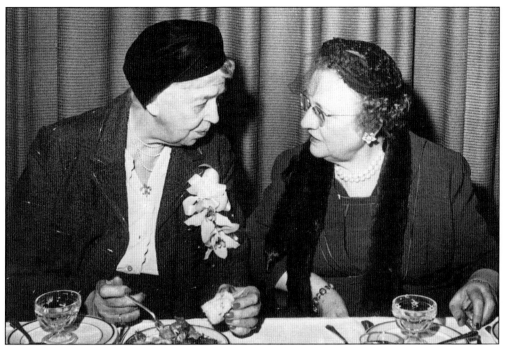

Dr. Margaret Bryant, a Trenton, South Carolina native, graduated in 1931 from Columbia University with a Ph.D. and went on to become a world-renowned linguist and professor of English at Brooklyn College in New York City. This photo shows Dr. Bryant (left) with Eleanor Roosevelt in 1959.

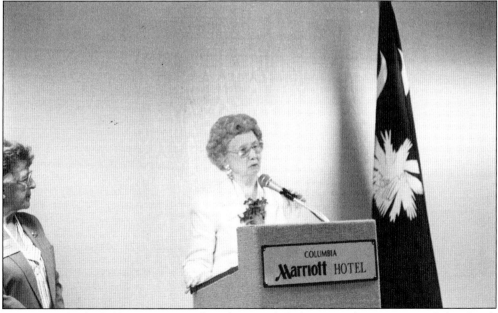

A native of Edgefield County, Martha Thurmond Bishop was the recipient of the South Carolina Commission on Women's first Pioneer Award in 1991. Before retiring in 1976, she educated countless students in South Carolina as a teacher in South Carolina Public Schools, at the Connie Maxwell Children's Home, and at Lander College.

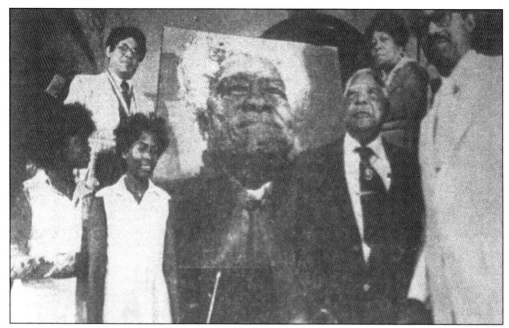

Mary McLeod Bethune (1875–1955) was one of the nation's most distinguished educators. A Maysville native, she was the daughter of former slaves; she was the 15th of 17 children, and the first to be born in freedom. She became an advisor to four U.S. presidents and the founder of Bethune Cookman College in Daytona Beach, Florida, on July 10, 1936. Bethune is the first African American (and the first woman) to be memorialized by a portrait in the South Carolina State House. In 1994, she was honored once more with a commemorative postage stamp.

The State Human Affairs Commission and National Council of Negro Women will sponsor the Unveiling of the Portrait of Dr. Mary McLeod Bethune July 10, 1976, 12:00 noon.

The Ceremony will be held in the Rotunda of the State House, Columbia, South Carolina.

A Recognition Banquet in the Ballroom of The Carolina Inn, 937 Assembly Street at 7:00 p.m. will climax the South Carolina Bicentennial Celebration.

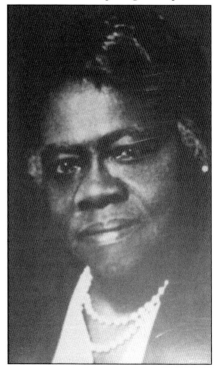

Dr. Rosamunde Boyd (1900–1993) was a faculty member at Converse College from 1937 until her retirement in 1971. Through her appointment on numerous committees at state and national levels, Dr. Boyd served as a role model for many women. Her numerous awards include the South Carolina Commission on Women's first Woman of the Year Award and the first Woman of the Year Award of the South Carolina Status of Women's Conference.

Cynthia Plair Roddey, a native of Rock Hill, integrated Winthrop University in 1964 when she became the institution's first black student.

Chester native Martha Marian Stringfellow was honored as the National Teacher of the Year in 1971.

In 1970, outstanding educator Mary Eva Hite (1888–1971) received a plaque from Elise Altman in recognition of being named Business and Professional Woman of the Year. Hite served as supervisor of teacher education for South Carolina from 1942 to 1957, executive secretary of the South Carolina Legislative Committee on Aging, state division president of the AAUW, and delegate to the 1961 White House Conference on Aging.

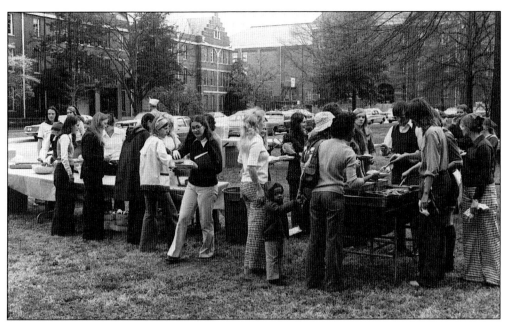

After 90 years of being a college for women, Winthrop became a co-educational institution in 1974.

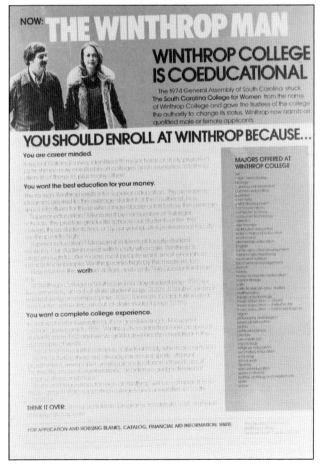

South Carolinian Terry Dozier was named National Teacher of the Year in 1985.

AAUW PALMETTO LEAF

American Association of University Women

VOL. XXXIII NO. 4 — **SOUTH CAROLINA DIVISION** — **June 1986**

GREENVILLE HOSTS CONVENTION

Speer — Holt

NEW DIVISION OFFICERS ELECTED

Three new officers of the S.C. Division were elected at the convention business session. Marlene Milstead, Rock Hill, was named President-Elect; Edythe Lambert, Clemson, Membership Vice President; and Barbara Moxon, Columbia, Recording Secretary. There were no nominations from the floor. Mable Stoudemayer, Greenville, served as chairman of the nominating committee.

CONVENTION ENDORSES GUSTAFSON

Convention delegates voted to endorse Judi Gustafson, past president of the division, for director of the South Atlantic Region. Long active in the Rock Hill Branch and in the division, she is currently serving as division bylaws chairman.

SUMMER WORKSHOP SET FOR JULY 12

Branch members should make plans now to attend the S.C. Division Summer Workshop/Board Meeting to be held Saturday, July 12, at the Town House, 1615 Gervais Street, Columbia.

Registration and coffee will start at 9 a.m. with the program starting at 9:30 a.m. Details of the program will be made available to branch presidents at a later date.

Cost of the workshop is $7 per person and includes registration, coffee and luncheon. Checks made payable to AAUW should be sent **before July 6** to:

Lelia White, Division President
P.O. Box 297
Denmark, SC 29042
Phone: 793-3086

Outstanding speakers, stimulating workshop sessions, presentation of Achievement Awards, and recognition of a new branch were among the highlights of the 62nd annual convention of the S.C. Division held April 18-20 in Greenville.

Dr. Margaret Holt of the University of Georgia, Dr. Gerda McCahan of Furman University, and Penny Kome, a feminist writer, were joined by Regional Director Helen Landers and Travel Visitor Cathy Speer, to head the slate of program participants. Barbara Moxon, Division Legislative Chairman, conducted one of the workshops. Division Vice President Betsy Moseley was in charge of programming.

Four division members were recipients of Achievement Awards during the banquet Saturday evening. Helen White, Rock Hill, received the Community Award; Ann Terry, Rock Hill, the Cultural Award; Grace Freeman, Rock Hill, the Education Award; and Jo Cartledge-Hayes, Spartanburg, the Women's Issues Award.

Hilton Head, former satellite of the Beaufort Branch, was officially recognized as a separate branch by President Lelia White. It is the division's 19th branch.

The treasurer's report was accepted, and the legislative program and an ad hoc project designed to revitalize the branches were approved during the business session Saturday. Election of three new division officers and the 1986-87 nominating committee followed on Sunday.

Eighteen branches and 86 registrants participated in the convention, according to Sara Mansbach, of the Greenville Branch. Sara Lochridge is the president of the host branch.

BYLAWS CHANGES MADE

Two bylaws changes were made at the convention. One adds a non-voting member, the chairman of the nominating committee for the previous year, to the division nominating committee. The other change makes membership in the division and a branch a prerequisite for holding a division office.

McCahan — Kome

The American Association of University Women has played a vital role in promoting the interests of women in South Carolina.

56

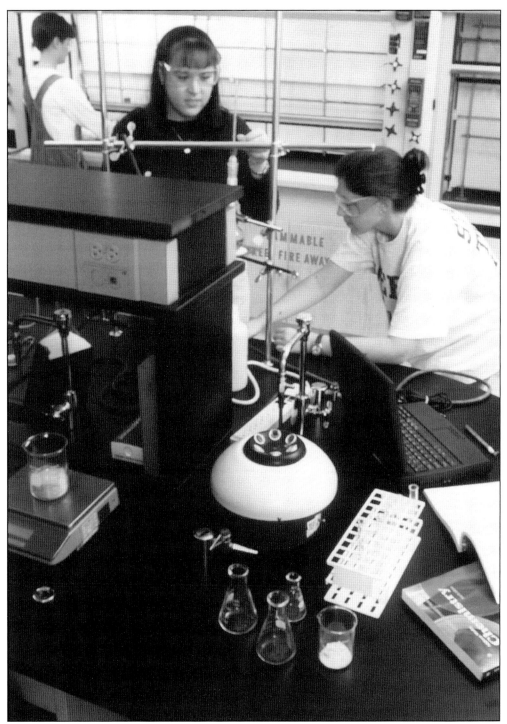

In this recent view of Columbia College, students Erin Ringus and Tara Truesdale are seen conducting a chemistry experiment in the Barbara Bush Center for Science and Technology. Among the college's most notable features are a nationally recognized honors program, a campus-wide collaborative learning approach, and a 14-1 student-faculty ratio.

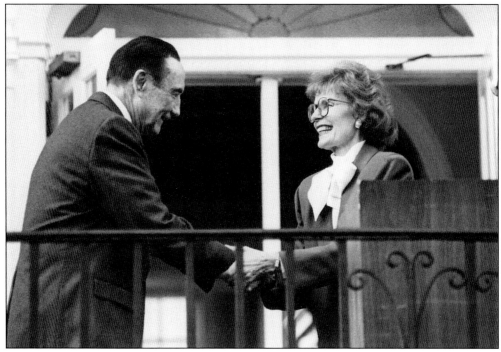

Martha Kime Piper, Winthrop president from 1986 to 1988, is seen here meeting with Senator Strom Thurmond in 1988. Dr. Piper was the first female president of Winthrop in its 100-year history. She died in 1988.

In March 1989, South Carolinian Anne L. Mathews went to Chicago to receive the prestigious John Robert Gregg Award for "contributions to the advancement of business education."

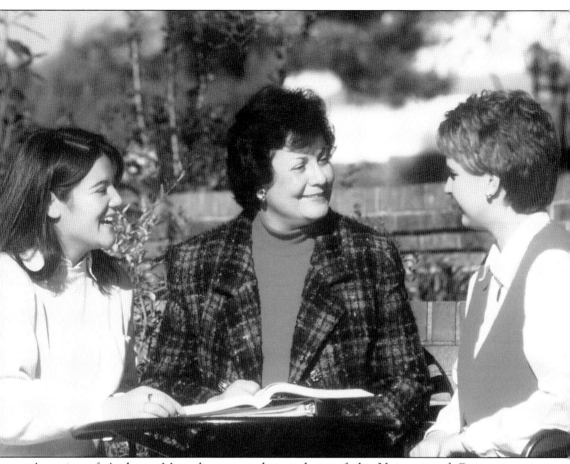

A native of Andover, Massachusetts, and a graduate of the University of Connecticut, Phyllis Bonnano is the current president of Columbia College. Prior to joining the college, she served as corporate vice president of International Trade at Warnaco, Inc., a worldwide Fortune 500 apparel manufacturing company.

The Women's Studies program at the University of South Carolina has played a special role in promoting and publicizing important issues affecting women in the state. Dr. Lynn Webb is current director of the program.

Converse College has had two female presidents in its 101-year history. Dr. Ellen Wood (1989–1993), seen left, and Sandra C. Thomas (1994–1998), pictured to the right.

The Winthrop Archives, like the other archives in South Carolina, has made a concerted effort to preserve records that document the many accomplishments and activities of women in the state.

Ann Evans is pictured here using a fumigator at the Winthrop University Archives.

Three

POLITICS AND
SOCIAL ACTIVISM

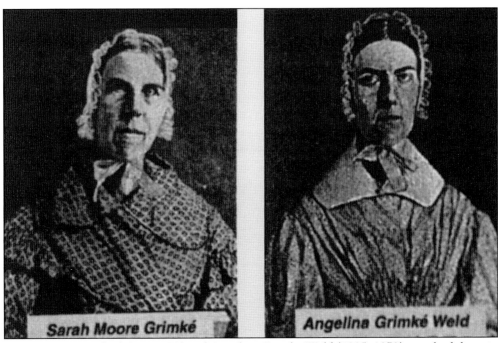

Sarah Moore Grimke

Angelina Grimké Weld

Sarah Moore Grimke (1792–1873) and Angelina Grimke Weld (1805–1879) were both born in Charleston to a large, wealthy, slave-holding family. Part of their year was spent in Charleston and the other at Belmont Plantation in Union County. These women were crusaders for the abolition of slavery and for equality for women; they were the first Southern white women to be crusaders for those causes. They moved from South Carolina to Philadelphia in the 1820s. Their views and actions were attacked not only by Southerners, but also by other abolitionists for bringing women's rights into the fight. They were inducted into the National Women's Hall of Fame in Seneca Falls, New York, on July 11, 1998.

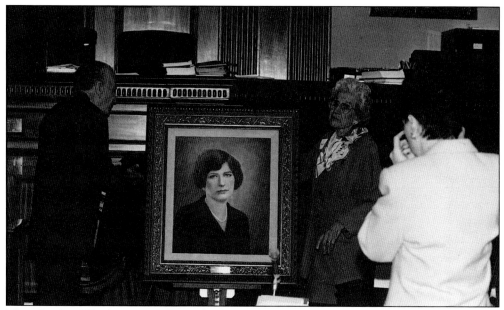

Mary Gordon Ellis (1894–1934) was the first woman to be elected to the General Assembly as a state senator. She was elected as a senator from Jasper County in 1928, and served one term, from 1928 to 1932. Mrs. Ellis, in addition to other issues, supported bills and amendments that would help improve the lives of women and African Americans. She died of cancer on September 9, 1934, ending a very promising political career. This photograph is a view of the unveiling of her portrait on the Senate floor on March 29, 1995.

Mary Elizabeth Frayser (1868–1968) was a pioneer in social betterment and equal suffrage in South Carolina. She was born and raised in Richmond, Virginia, but spent the majority of her long life in South Carolina. She came to Winthrop College in 1912 as the state agent for rural and mill-village community extension work. Over her years in South Carolina, she started one of the first night schools for mill employees in the state, and was involved with the South Carolina Interracial Relations Committee, South Carolina Congress of Parents and Teachers, League of Women Voters, South Carolina Federation of Women's Clubs, and the Federation of Business and Professional Women's Clubs. She also helped create the South Carolina public library system.

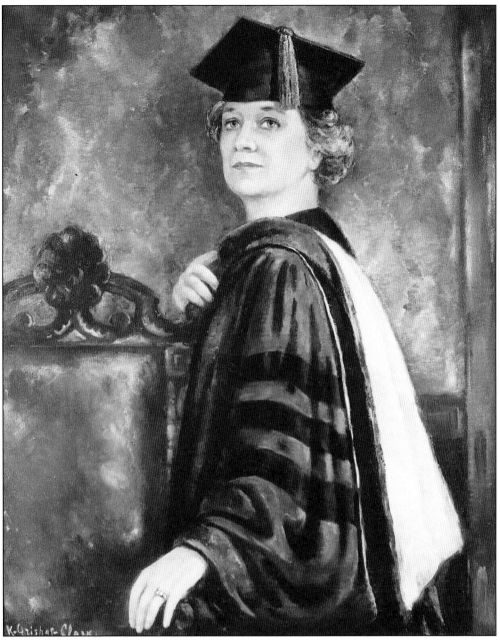

Eunice Ford Stackhouse (1893–1980) was one of South Carolina's most active club women and civic-minded citizens. Born in 1886 in Marlboro County, she worked tirelessly on behalf of adult education, better race relations, and the elderly.

FOR CONGRESS

Martha Thomas Fitzgerald

DEMOCRATIC PRIMARY
FEBRUARY 13, 1962

Your Vote is Your Weapon Against Tyranny.
Use it to Choose Your Own Representative—
Lose it by Letting Others Choose For You.

Martha Thomas Fitzgerald (1895–1981) was born in Cherokee County, and in 1950, became the first woman elected in a general election to the South Carolina House of Representatives. She represented Richland County from 1950 until 1962, when she decided to run for Congress and lost. She was an advocate for many causes, including women's service on juries.

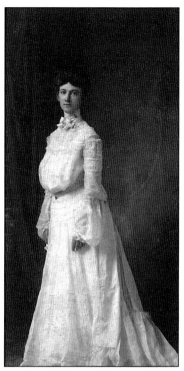

Christine South Gee (1884–1978) organized the first Council of Farm Women in the United States in 1921. She was born in Laurens County and graduated from Winthrop College in 1903. Pictured here, on the right, is Mrs. Gee in her graduation outfit. She was a state home demonstration agent from 1918 until 1923, when she married Dr. Nathaniel Gist Gee and went on to spend ten years in China. She served as a trustee of Winthrop from 1944 to 1962. In 1966, the school gave her the first honorary doctorate in its history. Mrs. Gee, Thomas Henry Jr., and Charles Davis (president of Winthrop) are pictured below.

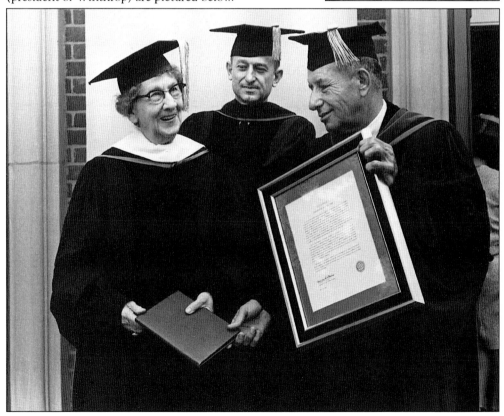

Modjeska Monteith Simkins was born in Columbia on December 5, 1899. She received her early education as well as her college degree from Benedict College, and did post-graduate work at Columbia University and the University of Michigan. She went on to teach for a number of years. As director of Negro Work for the South Carolina Tuberculosis Association, she promoted annual clinics and was commended for her work. In 1944, she volunteered as fund-raising director in a successful effort that provided $100,000 toward the construction of the Good Samaritan Waverly Hospital, the only hospital at the time to offer service to African Americans. Her work with the NAACP, Victory Savings Bank, civil rights, and community problems has also been commended.

Alice Spearman Wright was a respected member of the Civil Rights Movement in South Carolina. She worked with the Southern Regional Council, South Carolina Council on Human Relations, and the Commission on Interracial Cooperation. Pictured here, from left to right are as follows: Dr. Arnold Shankman, Alice Spearman Wright, Marion A. Wright, and Ann Y. Evans.

Nancy Stevenson was the first and only woman lieutenant governor of South Carolina. She served in this capacity from 1979 to 1982. Members of the South Carolina Commission on Women are pictured here, from left to right, as follows: Adele J. Pope, Nancy Stevenson, and Barbara Moxon.

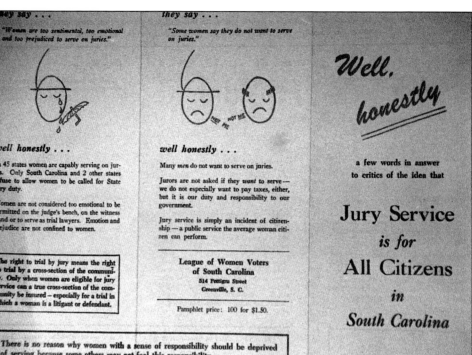

they say . . .

"Women are too sentimental, too emotional and too prejudiced to serve on juries."

well honestly . . .

In 45 states women are capably serving on juries. Only South Carolina and 2 other states refuse to allow women to be called for State jury duty.

Women are not considered too emotional to be permitted on the judge's bench, on the witness stand or to serve as trial lawyers. Emotion and prejudice are not confined to women.

The right to trial by jury means the right to trial by a cross-section of the community. Only when women are eligible for jury service can a true cross-section of the community be insured — especially for a trial in which a woman is a litigant or defendant.

they say . . .

"Some women say they do not want to serve on juries."

well honestly . . .

Many men do not want to serve on juries.

Jurors are not asked if they *want* to serve — we do not especially want to pay taxes, either, but it is our duty and responsibility to our government.

Jury service is simply an incident of citizenship — a public service the average woman citizen can perform.

League of Women Voters of South Carolina
514 Pettigru Street
Greenville, S. C.

Pamphlet price: 100 for $1.50.

Well, honestly

a few words in answer to critics of the idea that

Jury Service

is for

All Citizens

in

South Carolina

There is no reason why women with a sense of responsibility should be deprived of serving because some others may not feel this responsibility.

This brochure was part of the fight of South Carolina women to gain the right to serve on juries. That right was not achieved until 1967. The brochure points out the fallacies in some of the reasons given by those against it.

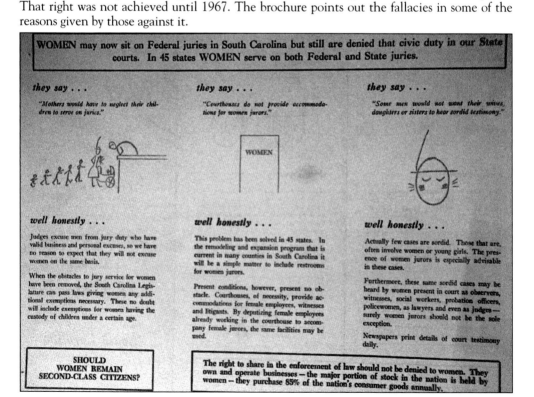

WOMEN may now sit on Federal juries in South Carolina but still are denied that civic duty in our State courts. In 45 states WOMEN serve on both Federal and State juries.

they say . . .

"Mothers would have to neglect their children to serve on juries."

well honestly . . .

Judges excuse men from jury duty who have valid business and personal excuses, so we have no reason to expect that they will not excuse women on the same basis.

When the obstacles to jury service for women have been removed, the South Carolina Legislature can pass laws giving women any additional exemptions necessary. These no doubt will include exemptions for women having the custody of children under a certain age.

SHOULD WOMEN REMAIN SECOND-CLASS CITIZENS?

they say . . .

"Courthouses do not provide accommodations for women jurors."

WOMEN

well honestly . . .

This problem has been solved in 45 states. In the remodeling and expansion program that is current in many counties in South Carolina it will be a simple matter to include restrooms for women jurors.

Present conditions, however, present no obstacle. Courthouses, of necessity, provide accommodations for female employees, witnesses and litigants. By deputizing female employees already working in the courthouse to accompany female jurors, the same facilities may be used.

they say . . .

"Some men would not want their wives, daughters or sisters to hear sordid testimony."

well honestly . . .

Actually few cases are sordid. Those that are, often involve women or young girls. The presence of women jurors is especially advisable in these cases.

Furthermore, these same sordid cases may be heard by women present in court as observers, witnesses, social workers, probation officers, policewomen, as lawyers and even as judges — surely women jurors should not be the sole exception.

Newspapers print details of court testimony daily.

The right to share in the enforcement of law should not be denied to women. They own and operate businesses — the major portion of stock in the nation is held by women — they purchase 85% of the nation's consumer goods annually.

Calendar No. S. 97

Introduced by JUDICIARY COMMITTEE

Printer's No. 201—H. Read the first time February 1, 1967.

THE COMMITTEE ON JUDICIARY

To whom was referred a Bill (S. 97), to ratify an amendment to Section 22, Article V, Constitution of South Carolina, 1895, etc., respectfully

REPORT:

That they have duly and carefully considered the same, and recommend that the same do pass.

HEYWARD BELSER, for Committee.

A BILL

To Ratify an Amendment to Section 22, Article V, Constitution of South Carolina, 1895, Relating to Trials by Jury so as to Permit Women to Serve on Juries.

Be it enacted by the General Assembly of the State of South Carolina:

SECTION 1. The amendment to Section 22, Article V of the Constitution of South Carolina, 1895, proposed under the terms of Joint Resolution No. 1136 of the Acts and Joint Resolutions of 1966, having been submitted to the qualified electors in the manner prescribed in Section 1 of Article XVI of the Constitution of South Carolina, 1895, and a favorable vote having been received thereon, is ratified and declared to form a part of the Constitution of South Carolina, 1895, so that Section 22, Article V is changed by striking the word "men" on line six and inserting the word "persons". Section 22 of Article V, Constitution of South Carolina, 1895, when amended shall read as follows:

"Section 22. All persons charged with an offense shall have the right to demand and obtain a trial by jury. The jury in cases civil

Anderson, S. C.
Oct. 16, 1966
P. O. Box 479

Dear State Presidents and State Legislation Chairmen:

As all of you know, jury service for women has headed the lists of our legislative activities for many years. For 25 or 30 years, we have talked about it, got bills introduced, asked for and attended hearings, and buttonholed our legislators, attempting to secure a referendum for an amendment to the State Constitution.

Now we have succeeded in that phase, and the vote is set for November 8. It is up to us what happens next. We cannot let this fail. If we do, we need never again go to the General Assembly for any legislation of any kind. It is my feeling that the referendum must not only be approved — but it must be approved by such a "landslide" that everyone will know the women of South Carolina are interested in bearing their share of the responsibility for good government and for all civic affairs.

I am including a "fact sheet" on jury service for women; a copy of the amendment as it will appear on the ballot; and a copy of the bill as it was passed by the General Assembly on the last day of the session. Incidentally, I was present in both Houses when the vote was taken. Due to the lack of funds, I cannot possibly send you enough copies to distribute to each club, but I do hope that you will reprint these to send your local legislation chairmen.

Let's "blitz" the people during these few days before the election! Ask the local presidents and legislation chairmen to get busy: to contact local daily and weekly newspapers and radio stations for interviews, spot announcements, debates, stories, pictures, anything they can dream up. I am contacting all the TV stations in the state in an effort to get some publicity that way, hoping that we can call on you leaders in each locality to appear.

Ask the local organizations to contact other women's clubs — offering them a speaker for about five minutes. Ask them to start telephone chains, with each person called to call at least two or three others: to make copies of the "fact sheet" for general distribution.

In football parlance, we have the ball, and it is third down and goal to go! It may be up to local groups whether to run, pass, or kick — but the objective is the same: touchdown!

Good luck! And if I can help in any way, just let me know. My address is listed above, and my phone number is 225-2797.

Sincerely,

Sara V. Liverance

(Mrs.) Sara V. Liverance
State Legislation Chairman, Council for the Common Good
" " ", Conference on the Status of Women

Shown here is a copy of the 1967 bill that gave women the right to serve on state juries This right was due to the efforts of Sara Vandiver Liverance, club member, journalist for the *Greenville News*, and chief of its Anderson Bureau from 1949 to 1974. Incidentally, she also persuaded the General Assembly to finally ratify the Nineteenth Amendment in 1969. South Carolina did not officially give women the right to vote until that time.

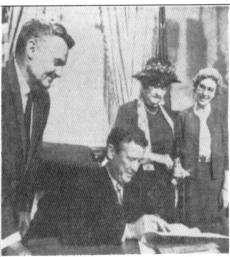

South Carolina women were finally given the right to vote officially in July 1969, when Gov. Robert McNair signed the measure to ratify the Nineteenth Amendment.

WOMEN'S SUFFRAGE APPROVED — South Carolina Gov. Robert McNair Tuesday signed a measure ratifying a U. S. constitutional amendment giving women the right to vote. Joining in the long-awaited ceremony (from left) were Aiken Sen. Gilbert McMillan; Mrs. Eulalie Salley of Aiken, long-time champion of women's suffrage; and Greenville Rep. Carolyn Frederick. (AP Wirephoto)

Carolyn Essig Frederick has been active in community efforts in Greenville for many years. She served as a member of the South Carolina House of Representatives from 1967 to 1976 and introduced legislation to establish the Status of Women Commission.

facts

League of Women Voters of South Carolina

1951 – 1971

The League of Women Voters in South Carolina, organized in 1951, is an organization whose purpose is to promote active and informed participation of all citizens in government and politics.

Juanita Willmon Goggins was born in Pendleton in 1934 and graduated from South Carolina State College. She was the first African-American woman to serve on the South Carolina House of Representatives. Elected from York County in 1975, she served until 1978.

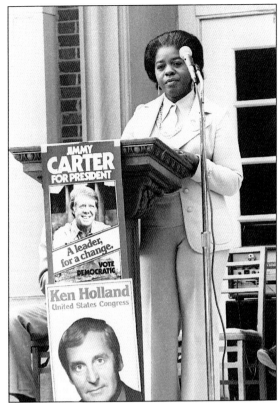

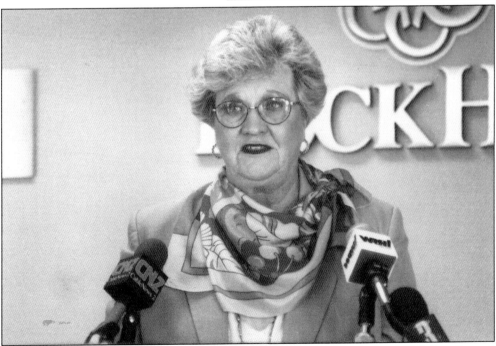

Betty Jo Rhea, a native of Rock Hill, was the first woman elected to the Rock Hill City Council in 1978 and the first female mayor. She served as mayor from 1986 to 1996.

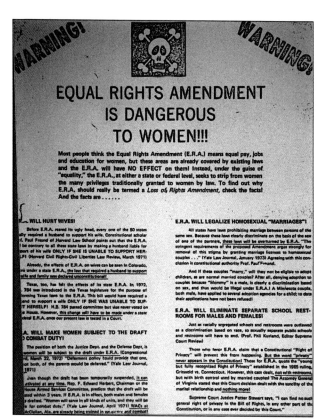

The Equal Rights Amendment (ERA), as these documents show, was one of the most controversial and volatile women's issues of the 20th century. The ERA was voted down when brought before the South Carolina General Assembly in 1978.

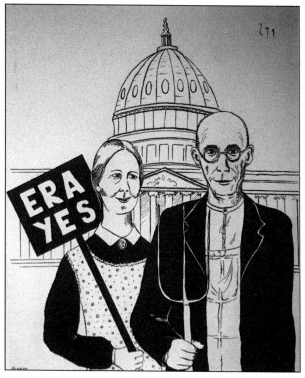

Mary Jeanne Byrd was a political science professor at Winthrop from 1969 to 1986. In 1979, she was the first woman to be appointed to the South Carolina Insurance Commission, where she served as chairman from 1985 to 1986. She has also served as the York County Democratic Party chairman and is very active in the Democratic Party.

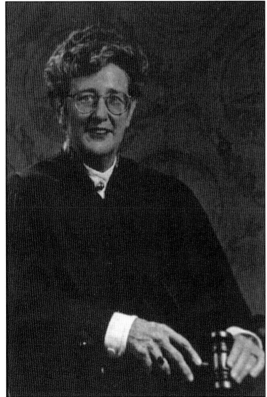

Jean Hoefer Toal, born in 1943 in Columbia, graduated from Agnes Scott College with a degree in philosophy and received her law degree from the University of South Carolina in 1968. She served as a member of the South Carolina House of Representatives for 13 years. In 1988, she became the first and only woman to be elected to the South Carolina Supreme Court. She was re-elected in 1996. Her term ends in 2006.

Bessie Moody-Lawrence (left), a native of Chester County, is an assistant professor of education at Winthrop University. She is serving her fourth term as representative from House District 49.

Although Harriet H. Keyserling grew up in New York City, she has spent more than 50 years in South Carolina. She served in the S.C. House of Representatives from Beaufort from 1977 to 1992.

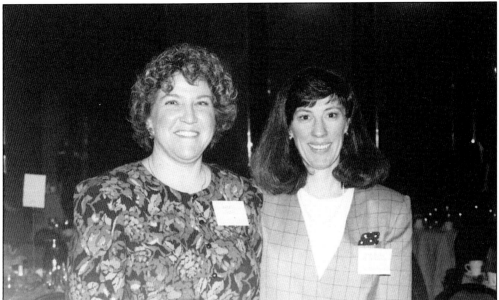

Mary Waters became the director of the South Carolina Commission on Women in 1992. She is a passionate advocate for women's rights. Shown above is Susan Davis (left) and Mary Waters (right). A copy of the commission's newsletter is seen in the photograph to the right.

SOUTH CAROLINA
WOMEN

A QUARTERLY NEWSLETTER OF THE SOUTH CAROLINA
WINTER/SPRING 1989 COMMISSION ON WOMEN VOL 9 NO. 3/4

Commission on the Future of South Carolina presents its final report to a Joint Assembly of the Legislature on February 22. Three women served on the Commission.

Women prepare to face challenge of the future

One question has long fascinated humankind: what does the future hold?

No one can say for sure, but as the 21st century draws near, public policy makers are monitoring trends and preparing for the possibilities.

In South Carolina the Commission on the Future identified education, the living environment, economic development and government as critical planning areas. These four topics were discussed in depth and debated at length by 150 South Carolinians during the Assembly on the Future last fall.

Across the country, educational institutions, state agencies, business leaders, local governments and individuals are developing strategies to meet the challenge of the future.

Women are also interested in knowing what the future may hold for them. What changes in workplace, home and community are likely to occur? How might women prepare themselves --and their daughters--for success in the new century?

This issue of **South Carolina Women** identifies current trends and explores future possibilities. And while no one can say for sure what the future may hold, it may be said that those who anticipate the opportunities may be better prepared to take advantage of them.

Women, Work and the Future
National Commission on Working Women of Wider Opportunities for Women (WOW)

*From 1989 through the year 2000, 2 of every 3 new entrants to the labor force will be women.

*Nearly 90 percent of jobs created between now and the year 2000 will be in the service sector. Five of the 11 occupations projected to create the largest number of new jobs over the next decade are now female dominated occupations with median weekly wages below the poverty level.

*Part-time or temporary employment will comprise an increasing share of available jobs. Part-time and temporary jobs typically provide few or no benefits, limited job security, lower wages and few opportunities for advancement.

*For the first time in history, a majority of all new jobs will require education or training beyond high school.

*Women and girls continue to be disproportionately enrolled in education and training that prepares them for low-wage jobs in traditional female occupations.

*JTPA does not provide adequate support services to enable women to participate fully in literacy and job training programs. A majority of women in JTPA programs are training for female-dominated, low wage clerical and service jobs.

*Literacy needs for the future work force: good basic skills in reading, writing and math; higher order and critical thinking skills; analytical and problem-solving skills; communications skills; basic computer skills; team work skills.

Commission on Future report available from office of Lt. Governor

The Commission on the Future of South Carolina started work in 1987 to "develop a long-term strategy for the state in order to anticipate the needs and demands of its citizens for the 21st century."

Two years and two documents later, the 31-member, bi-partisan commission has completed its task and presented its final report and recommendations to the S.C. Legislature.

The Commission on the Future identified and researched four critical planning areas and invited 150 South Carolinians to debate the issues at the Assembly on the Future, held last fall in Hilton Head.

About half the Assembly participants were women. The Commission on the Future had three women members: Noree Boyd-Leopard, Joyce T. Marshall, and Mim Woodring. Before her death, Dr. Martha Kime Piper, president of Winthrop College, served as vice-chair.

Both the Assembly report and the Commission on the Future executive summary are available through the Office of the Lieutenant Governor, PO Box 142, Columbia, SC 29202 (734-2080).

S.C. Commission on Women

page 1 focus

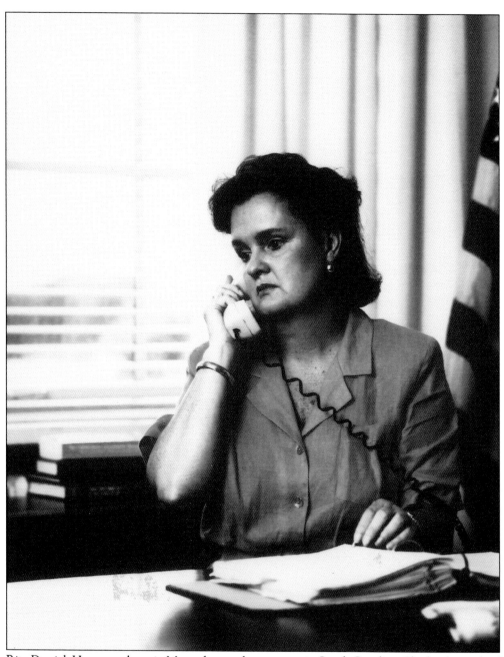

Rita Derrick Hayes was born in Massachusetts but grew up in South Carolina. She has been chief of staff for Representative Liz Patterson and Representative John Spratt. She was appointed as the U.S. ambassador to the World Trade Organization in 1997.

Four

ARTS AND SPORTS

WINTHROP COLLEGE—DEPARTMENT OF MUSIC.

PUPILS' RECITAL.
with the assistance of
Miss Celeste Louise Seymour, Violinist.
COLLEGE AUDITORIUM.
Thursday Evening, December 24, 1896, at 8 o'clock.

...Programme...

SPANISH DANCE (arranged for Three Pianos) *Moszkowski.*
MISSES LIBBIE SPENCER, PAWNEE JONES, JENNIE RUSSELL,
MAY WILLIAMS, HEYDIE BROWN AND MAUD GARDNER.

SONG—My Lady's Bower, *Hope Temple*
MISS MAE O'BRYAN.

IMPROMPTU OP. 29, A-Flat Major, *Chopin*
MISS MARGARET ROACH.

VIOLIN SOLO—Hungarian Rhapsody, *Hauser*
MISS SEYMOUR.

POLISH DANCE—E-Flat Minor (Two Pianos) . . *X. Sharwenka*
MISSES JEANIE SPRUNT, BESSIE LYLES, SADIE LEE AND
EDITH STEWART.

SONG—Voices of the Woods, *Rubenstein-Watson*
MISS LUCILLA BOOKER.

AU LOUET—(At the Spinning Wheel) *Godard*
MISS LONA TILLMAN.

SONG—To Thee, *Guy d' Hardelot*
MISS ANNIE OATES.

POLKA DE LA REINE, *Raff*
MISS GEORGIE STEEDLY.

VIOLIN SOLO—{ a Cavatina, *Raff*
{ b Kujawiak, Second Mazurka, . . *Wieniawski*
MISS SEYMOUR.

JUBILEE OVERTURE—(Two Pianos) *Weber*
MISSES STEEDLY, ROACH, TILLMAN AND EDNA DIVVER.

The Winthrop College Department of Music was an early training ground for South Carolina's aspiring female musicians.

Annie Vredenburgh Dunn was born September 14, 1876, in St. Thomas, Canada, but was raised in Macon, Georgia. She came to Winthrop College in 1907 as an art instructor and retired as head of the Department of Fine Arts 40 years later. Her work at Winthrop was highly respected by her students and the school. She died on March 16, 1966.

Lily Strickland was born in Anderson on January 28, 1887. Her talent for music was first recognized when she was a child; she was in her teens when she began composing. After graduating from Converse College in 1904, she went on to study at the Institute of Musical Art in New York. The composer of nearly 400 pieces, Strickland died on June 6, 1958.

Lucile (Ludy) Godbold, a native of Estill, won two gold medals and four other medals in Paris in 1922 at the First International Track Meet for Women. The gold medals were for the shot put and hop-step-jump. At this time, women were barred from Olympic competition; the meet was considered the forerunner to women's participation.

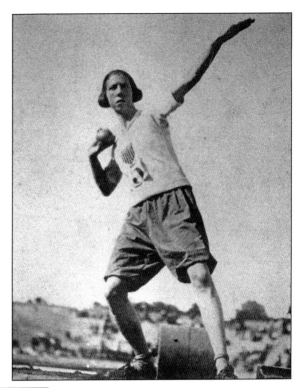

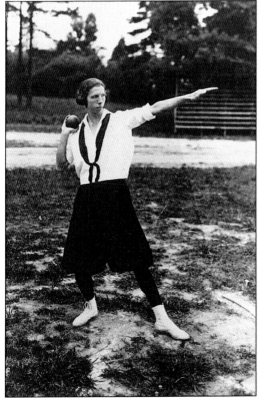

A graduate of Winthrop College, Godbold became a physical education instructor at Columbia College in 1924. She taught there for 58 years. In 1961, she was the first woman to be inducted into the South Carolina Athletic Hall of Fame. She died in 1981, at the age of 80.

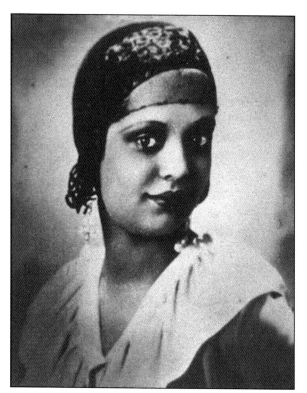

Nina Mae McKinney of Lancaster County was a movie actress in the late 1920s and 1930s. She appeared in such films as *Reckless*, *The Lost Lady*, and *In Old Kentucky*. In the 1930s, she toured Europe and, while in England, co-starred with Paul Robeson in *Sanders of the River*. In the 1940s and 1950s, she worked in the theater and cabarets and appeared in films including *Without Love* and *Night Train to Memphis*. She died in 1967.

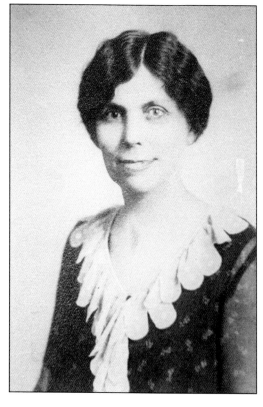

Barnett Spratt was born in Chester on March 7, 1894. She was primarily a teacher, but her interest in children led her to write books for them. She wrote *Tom and the Red Coats*, *Toppy and the Circuit Rider*, and *Miss Betty of Bonnet Rock School*. The latter is set in Chester County, where there is a landmark known as Bonnet Rock. The others are also set in South Carolina. She died on February 14, 1981.

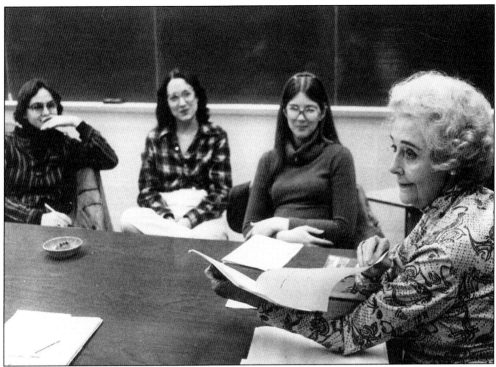

Elizabeth Boatwright Coker is a South Carolina novelist who graduated from Converse College in 1929. Her novels include *India Allen*, *La Belle*, *Blood Red Roses*, and *The Grasshopper King*.

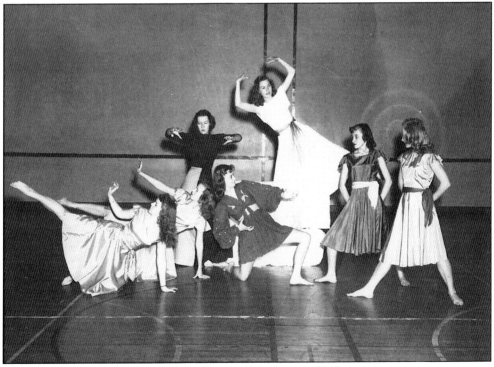

These women are performing modern dance at Winthrop in 1948.

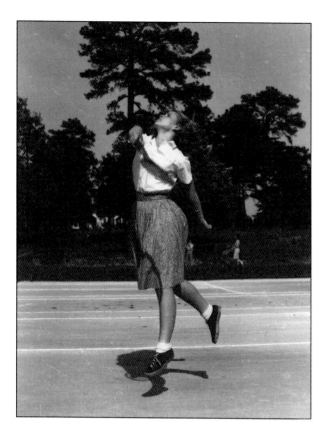

Young women in South Carolina have participated in sports throughout the years. Shown in the image to the left is a girl playing tennis. Below is a high school basketball team, photographed in the 1940s.

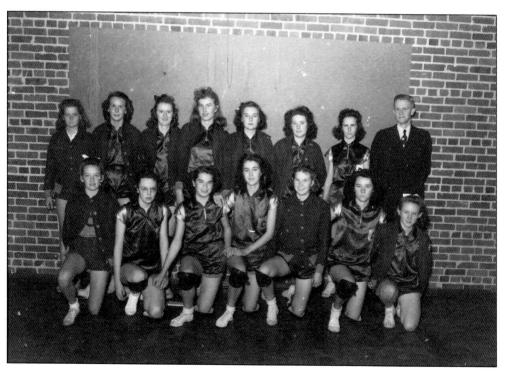

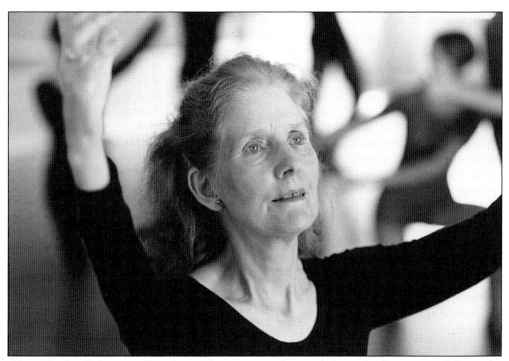

Alice Hayden Salo was a Winthrop University professor of physical education and dance for 32 years. Her love of dance was evident in all of her work. She compiled a history of dance instruction and performance at Winthrop before she died in 1996.

Martha Bray Carson was a native of Fairfield County but lived most of her life in Chester County. She was a state president of the South Carolina United Daughters of the Confederacy and wrote many historical articles for their magazine. In 1950, she wrote the following salute to the South Carolina flag: "I salute the Flag of South Carolina and pledge to the Palmetto State love, loyalty and faith." In 1966, the South Carolina General Assembly officially adopted the salute. Mrs. Carson died in 1953.

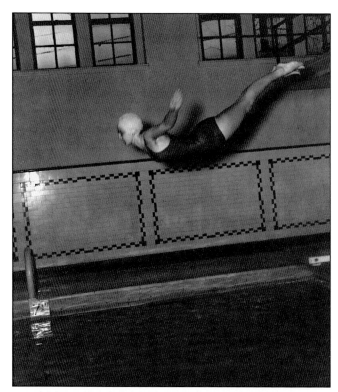

Swimming is a popular South Carolina pastime. These are swimmers at Winthrop's old Peabody Gymnasium pool. Learning to swim used to be a requirement for graduation at Winthrop.

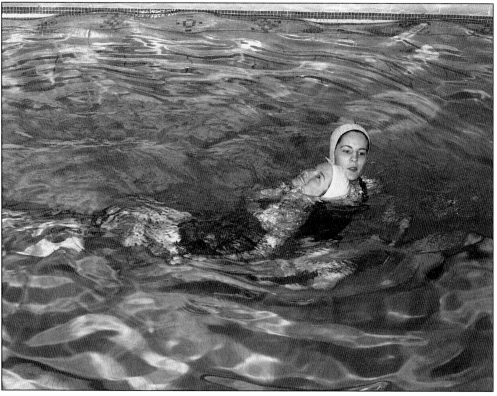

Carroll Glenn, violinist, began to play the violin at the age of four, under her mother's tutelage in Chester. Later, she continued her studies with Felice de Horvath in Columbia. She went to New York to study at the Juilliard School, where she graduated at age 15. Glenn won numerous awards and accolades over her career and married pianist Eugene List in 1943. They toured extensively together. In later years, she taught music at North Texas State University, Temple University, the National Music Camp at Interlochen, the Eastman School, the Manhattan School, and Queens College, CUNY. Her last concert tour was in 1981 to China. She died in 1983.

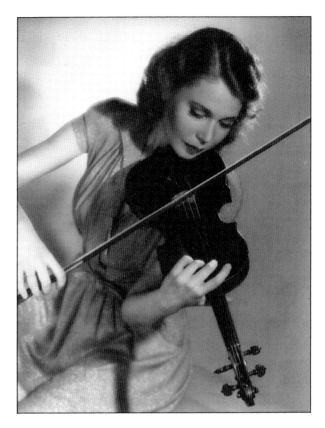

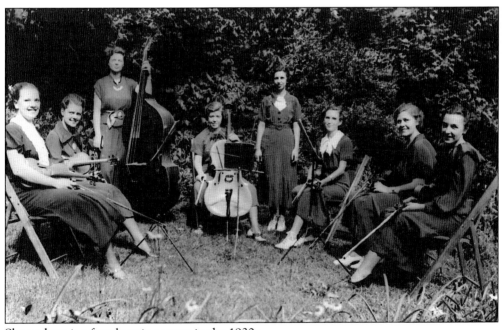

Shown here is a female string group in the 1930s.

Until her death in 1974, Dr. Mary Elizabeth Massey, professor of history at Winthrop College, was one of South Carolina's most distinguished professors. She authored several books on Southern history, including *Bonnet Brigades* and *Ersatz in the Confederacy*, as well as engaging in research on women in the War Between the States.

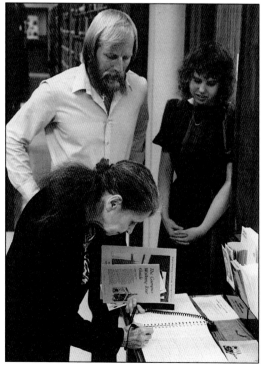

Mina Surasky Tropp was known as a collagist and painter with flora. Her artwork is an intriguing mix of paint and preserved flowers and plants. She was a native of Aiken County. In this 1982 photograph, Mrs. Tropp is seen visiting the Winthrop Archives.

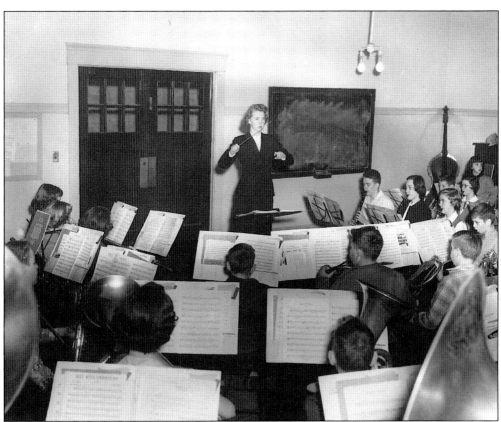

Whether teaching or performing, women have had an influence on music in South Carolina. Above is a band class c. 1948, and to the right is Pat Gunn at the piano c. 1958.

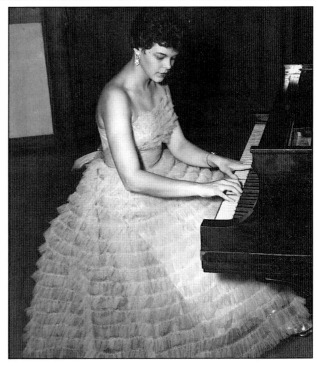

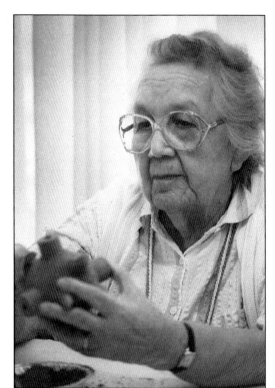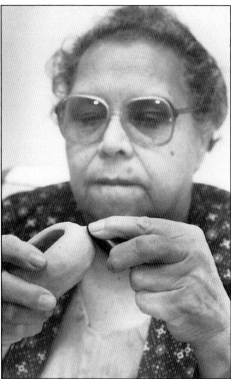

Georgia Harris, a Lancaster native, and Mildred Blue were two master Catawba Indian potters. Catawba pottery is a unique art form. The technique has been passed down from generation to generation.

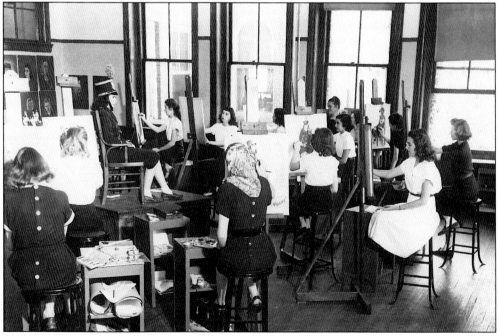

This scene is of a painting class at Winthrop in 1947.

Annie Greene Nelson is South Carolina's first-known, published African-American female author. A native of Darlington County, she has written many novels and plays, including *After the Storm*, *The Dawn Appears*, *Shadows of the South Land*, and *Weary Fireside Blues*.

Frances Patton Statham is a native of Rock Hill and a 1951 graduate of Winthrop. Her 1986 novel, *To Face the Sun*, won the National Review's Choice Award for the best WW II novel. She presently resides in Georgia.

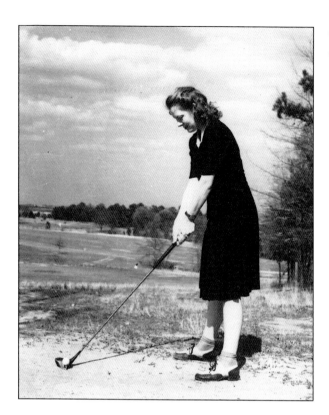

This woman enjoys a day of golf in the 1940s.

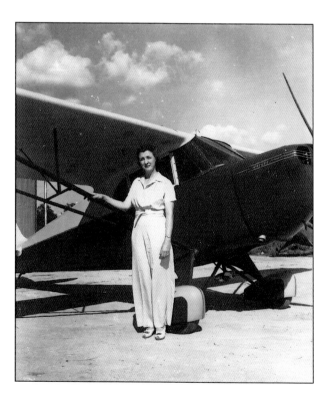

In the late 1940s, women began participating in flying and other sports activities that were usually designated for men.

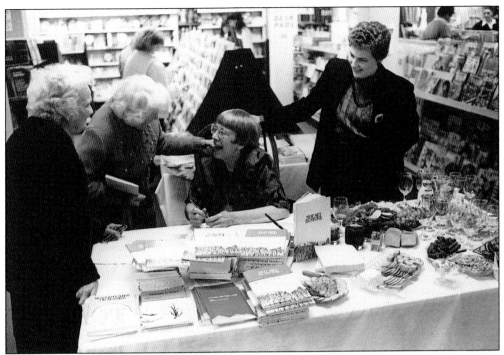

Grace Beacham Freeman, a native of Spartanburg and a graduate of Converse College, has been a poet with the South Carolina Arts Commission's Poets-in-the-Schools Program and a consultant in poetry therapy. Named poet laureate of South Carolina in 1985, Freeman has published a number of poetry books, including *No Costumes or Masks*. Shown here, seated at the table, she is signing some of her books in 1986.

Poet Susan Ludvigson has been a professor of English at Winthrop University since 1975. She has received Guggenheim, Fulbright, and National Endowment for the Arts fellowships. Her work includes *Step Carefully in Night Grass*, *Northern Lights*, and *The Swimmer*.

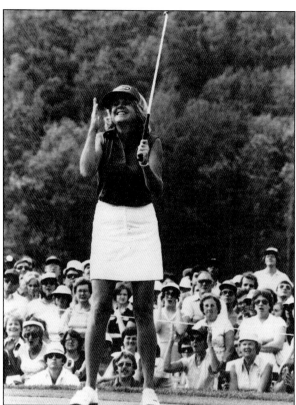

Kathy Hite is a 1970 Winthrop graduate. She has had a long career on the Ladies Professional Golf Association (LPGA) tour.

Pictured in this 1958 view is the girls' basketball team from Jefferson High School in York.

94

Poet Dorothy Perry Thompson grew up in Columbia. A graduate of Allen University, she earned her Masters and Ph.D. degrees from the University of South Carolina, where she studied under James Dickey. She is presently a professor at Winthrop University teaching composition, poetry writing, and literature.

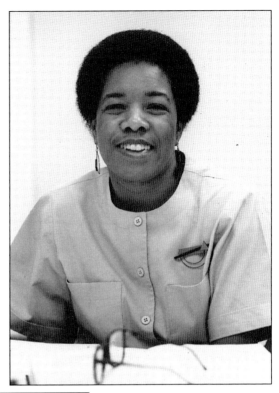

Idella Fallaw Bodie is a native of Ridge Spring who presently resides in Aiken. After graduating from Columbia College, she taught English and creative writing for more than 30 years. She has written 12 books about South Carolina history for young readers and continues to write more.

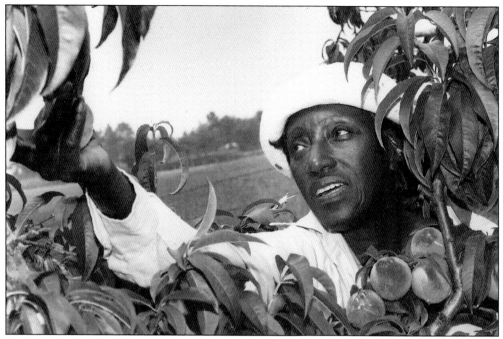

Dori Sanders is a York County peach farmer and a best-selling author. Her works include *Clover* and *Her Own Place*.

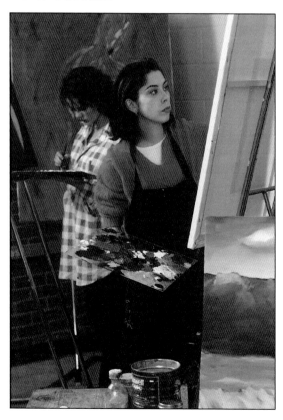

Columbia College art majors Jacqueline Keane (foreground) and Elizabeth Edson prepare works for a student show.

Five

PROFESSIONS

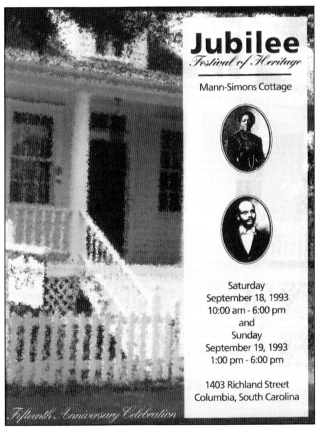

This is a program note celebrating the 50th anniversary of the annual Jubilee Festival of Heritage, which is sponsored by the Mann-Simmons Cottage of Columbia. The Mann-Simmons Cottage was the home of Celia Mann, who in the mid-1880s bought her freedom in Charleston and walked with her four daughters to Columbia. Located at 1403 Richland Street in Columbia, the home is listed on the National Register of Historic Places and serves as a museum dedicated to educating the public about African-American culture.

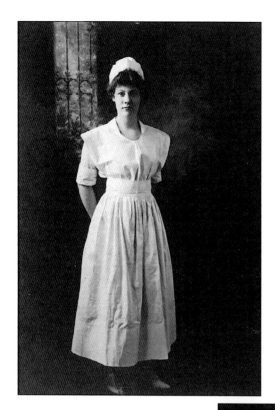

In the early part of the 20th century, Florence Evelyn Goodson was a nurse in Florence's South Carolina Infirmary. At the time, nursing was one of the few professions open to women.

Described as the "Angel of Mercy," Maude Callen became famous as a midwife and as a volunteer who helped make the last days of many of the state's poor, aged citizens comfortable. From 1923 to 1983, she helped bring much-needed health services to the impoverished area of Pineville. Ms. Callen is a member of the South Carolina Hall of Fame.

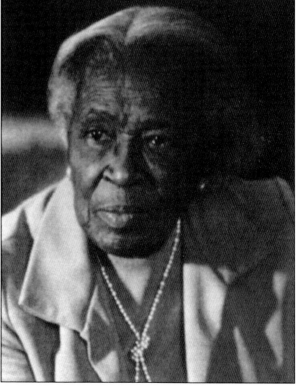

Affectionately known as Mother Walker, Dora Dee Walker (1862–1951) was South Carolina's first home demonstration agent. In her pioneering work with farm communities, she left a positive, lasting impact on the state's development.

Ida Jane Dacus was the first certified librarian in South Carolina history. She served as head of the Winthrop University's Library from 1899 to 1945. The library is named in her honor.

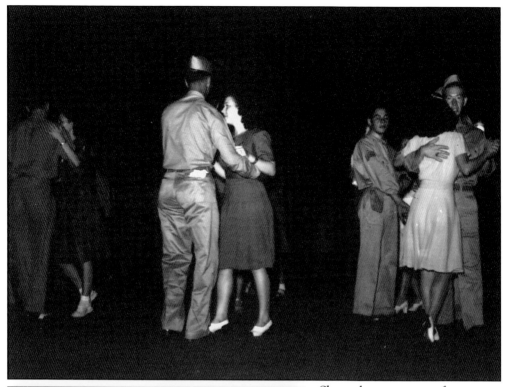

Shown here are scenes from the WW II years. While the men were off fighting the Axis powers, South Carolina women were playing an important role on the home front to support the war effort.

The Winthrop Archives contains a diary titled, *My War Diary*, which was written by South Carolinian Lucy Hardee Olsen. The fascinating document describes Olsen as an American held in the Philippine Islands by the Japanese during WW II. Olsen is seen on the left in this photo.

This 1940s photo illustrates a stark fact: for much of this century, occupations for women were mainly limited to such occupations as office secretary.

By the 1990s, times had changed.

A native of Lander, Frances Lander Spain used her skills and experience as a Fulbright Scholar to establish the modern library movement in Thailand from 1951 to 1952. Dr. Spain is a former president of the American Library Association and a longtime children's librarian at the New York Public Library. She died in 1999.

The Crisis In Education And Federation

As this page from *The South Carolina Club Women* shows, educational matters and issues have long been a concern of women in South Carolina. This publication was produced by the South Carolina Federation of Women's Clubs.

This 1959 photo shows Mrs. John H. Marshall, vice president of Rock Hill Pine Lakes Garden Club, discussing with fellow officers the new books she distributed at the club's annual luncheon meeting.

Through its many affiliates, the National Council of Jewish Women has made an impact on the state and nation.

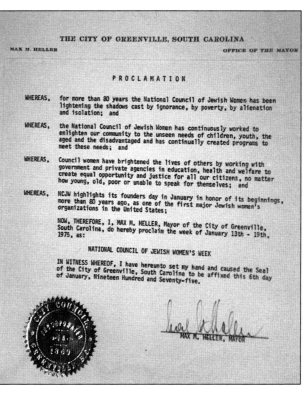

THE CITY OF GREENVILLE, SOUTH CAROLINA

MAX M. HELLER OFFICE OF THE MAYOR

PROCLAMATION

WHEREAS, for more than 80 years the National Council of Jewish Women has been lightening the shadows cast by ignorance, by poverty, by alienation and isolation; and

WHEREAS, the National Council of Jewish Women has continuously worked to enlighten our community to the unseen needs of children, youth, the aged and the disadvantaged and has continually created programs to meet these needs; and

WHEREAS, Council women have brightened the lives of others by working with government and private agencies in education, health and welfare to create equal opportunity and justice for all our citizens, no matter how young, old, poor or unable to speak for themselves; and

WHEREAS, NCJW highlights its founders day in January in honor of its beginnings, more than 80 years ago, as one of the first major Jewish women's organizations in the United States;

NOW, THEREFORE, I, MAX M. HELLER, Mayor of the City of Greenville, South Carolina, do hereby proclaim the week of January 13th - 19th, 1975, as:

NATIONAL COUNCIL OF JEWISH WOMEN'S WEEK

IN WITNESS WHEREOF, I have hereunto set my hand and caused the Seal of the City of Greenville, South Carolina to be affixed this 6th day of January, Nineteen Hundred and Seventy-five.

MAX M. HELLER, MAYOR

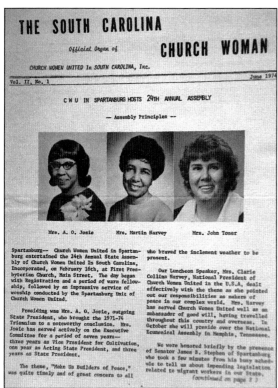

THE SOUTH CAROLINA
CHURCH WOMAN
Official Organ of
CHURCH WOMEN UNITED In SOUTH CAROLINA, Inc.

Vol. II, No. 1 June 1974

C W U IN SPARTANBURG HOSTS 24th ANNUAL ASSEMBLY

— Assembly Principles —

Mrs. A. O. Josie Mrs. Martin Harvey Mrs. John Toser

Spartanburg— Church Women United in Spartanburg entertained the 24th Annual State Assembly of Church Women United In South Carolina, Incorporated, on February 16th, at First Presbyterian Church, Main Street. The day began with Registration and a period of warm fellowship, followed by an impressive service of worship conducted by the Spartanburg Unit of Church Women United.

Presiding was Mrs. A. O. Josie, outgoing State President, who brought the 1971-74 Triennium to a noteworthy conclusion. Mrs. Josie has served actively on the Executive Committee for a period of seven years—three years as Vice President for Cultivation, one year as Acting State President, and three years as State President.

The theme, "Make Us Builders of Peace," was quite timely and of great concern to all

who braved the inclement weather to be present.

Our Luncheon Speaker, Mrs. Clarie Collins Harvey, National President of Church Women United in the U.S.A., dealt effectively with the theme as she pointed out our responsibilities as makers of peace in our complex world. Mrs. Harvey has served Church Women United well as an ambassador of good will, having travelled throughout this country and overseas. In October she will preside over the National Ecumenical Assembly in Memphis, Tennessee.

We were honored briefly by the presence of Senator James B. Stephen of Spartanburg who took a few minutes from his busy schedule to tell us about impending legislation related to migrant workers in our State.

(continued on page 7)

Church Women United in South Carolina is a bi-racial women's organization that works for the betterment of social and economic conditions in the state.

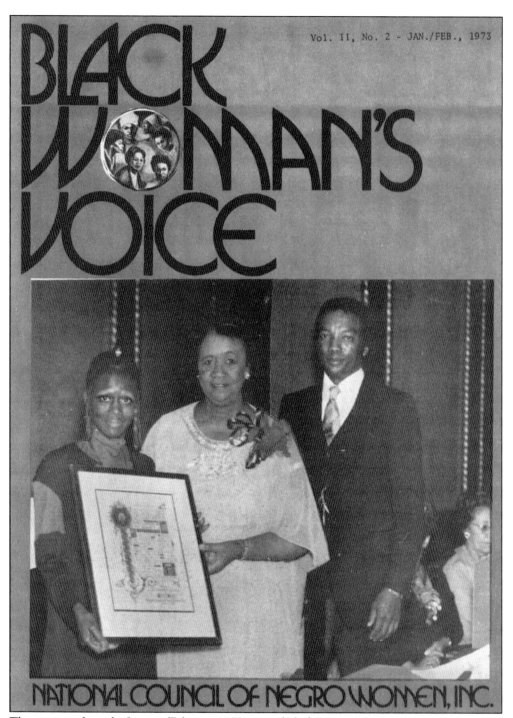

Vol. II, No. 2 - JAN./FEB., 1973

BLACK WOMAN'S VOICE

NATIONAL COUNCIL OF NEGRO WOMEN, INC.

This is a page from the January/February 1973 issue of *Black Women's Voice*, the newsletter of the National Council of Negro Women. For much of the 20th century, the South Carolina branches of the council have worked on issues affecting the welfare of African-American women.

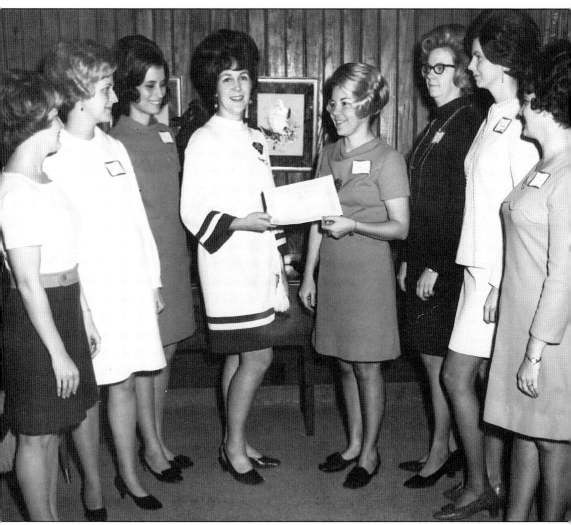

The York Jaycettes celebrate Charter Night in 1969.

In 1955, the Carolina Club of the South Carolina Business and Professional Women's Club celebrated its 25th anniversary, and as an anniversary Bicentennial gift, it presented an appropriately engraved silver card tray to the South Carolina's Governor's Mansion. The state's First Lady, Mrs. James Edwards, is seen accepting the tray. Surrounded by club president Mrs. Mary Clay and other club officers, Mrs. Eunice Leonard (center) is seen giving a presentation to the group.

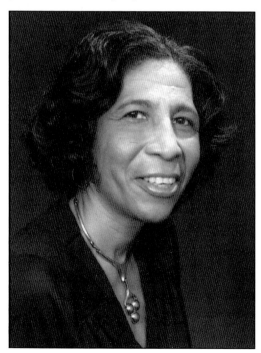

In 1965, Johnette Edwards, a native of Barnwell, became the first woman employed by the South Carolina Department of Mental Retardation. She was also appointed to the South Carolina White House Conference on Children and Youth and the President's Committee on Employment of the Handicapped.

York County native Pat Moss Guerry's beauty and singing talent earned her numerous awards, including Miss Universe of South Carolina.

Business and professional women's clubs have played an active role in the state's economic and community life. Here, members of the Business and Professional Women's Club of Spartanburg

celebrate their 17th anniversary in 1951.

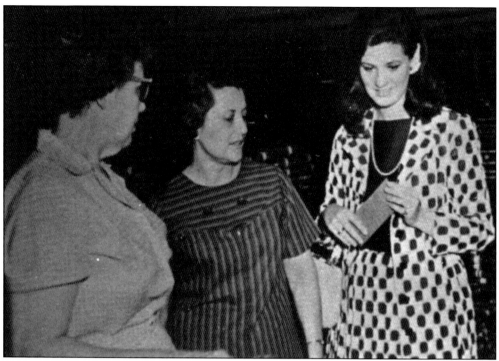

In 1969, Clover native Becky Lou Smith was voted Miss South Carolina. Here she is seen touring the former Bleachery plant in Rock Hill.

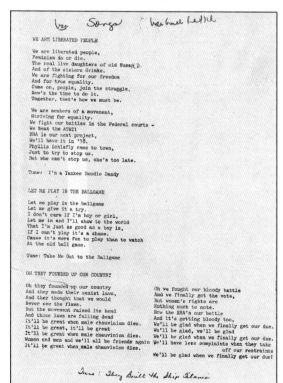

The Women's Movement became a force in the 1970s. These songs are from skits presented by the Greenville Feminist Theater.

Mrs. Alberta Grimes has the distinction of being the first African-American guidance counselor in the Greenville County School System.

In 1977, the Charleston chapter of the National Organization of Women (NOW) sponsored the first annual Mr. USA contest as a spoof on the traditional Miss USA beauty contest.

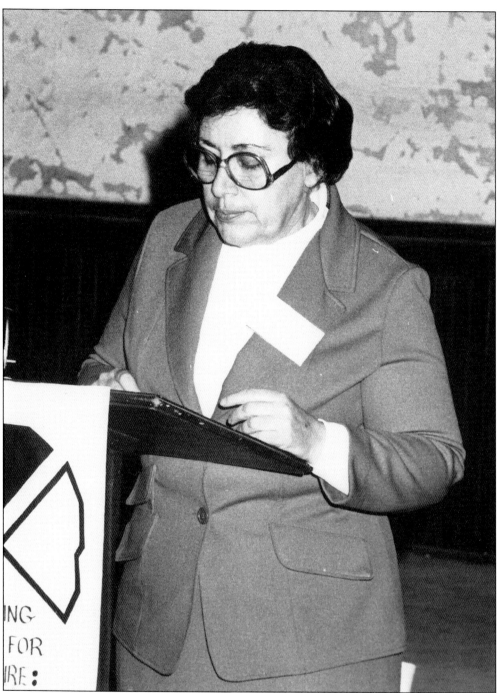

ING
FOR
RE:

Many South Carolina historians believe in sharing their knowledge and scholarship with the public. One of them is Louise Pettus, professor emeritus at Winthrop University, who continues to lecture and publish extensively on the state's history. Seen here at a conference in 1980, Pettus gives a presentation entitled "Preserving the Past for the Future: Local History and the Community." The conference was held at the Old Brick Presbyterian Church in Lancaster and sponsored by the Winthrop Archives.

\mathscr{S}tate of \mathscr{A}laska

THE LEGISLATURE

IN MEMORIAM - DR. MARTHA WILSON

The Legislature is deeply saddened to learn of the passing of a long-time Alaskan; a distinguished member of the medical community, and a woman much admired and respected.

Dr. Martha Richardson Wilson arrived in Sitka Alaska early in 1959. Shortly thereafter, in 1961, she assumed a post as Unit Director for the United States Public Health Service at Anchorage. "Dr. Martha", as she was best known, was recognized nationally several times for her work in Alaska. In the early days of statehood she helped suppress widespread tuberculosis. As director of program development for the Alaska Area Native Health Service she pioneered use of a television-satellite system to provide modern medical advice to the bush. She also devoted a great deal of time to alcohol rehabilitation and counselling in the Anchorage area besides initiating environmental studies that won her an appointment to the advisory board to the Department of Environmental Conservation in the early 1970's. Recently Dr. Wilson was named "Physician of the Year" by the Alaska State Medical Association.

Throughout her career serving Alaskans Martha Wilson maintained the respect and admiration of co-workers and of those she sought to help. Her spirit and leadership have provided motivation to many ideas and individuals. She will be deeply missed.

We extend sincere sympathy to her husband, Dr. Joe Wilson and to their sons, Joseph Jr. and Riley, and daughters, Mary and Frances. Be assured we recognize the contribution to Alaska made by this fine woman. We share your loss.

SPEAKER OF THE HOUSE PRESIDENT OF THE SENATE

Date: May 14, 1980

Requested by: Senator Colletta and Representatives
 Hayes and Martin

Martha Richardson Wilson left South Carolina for Alaska and made an impact there as a physician, pioneering the use of the television satellite system to provide modern medical treatment and consultation to people in rural parts of Alaska.

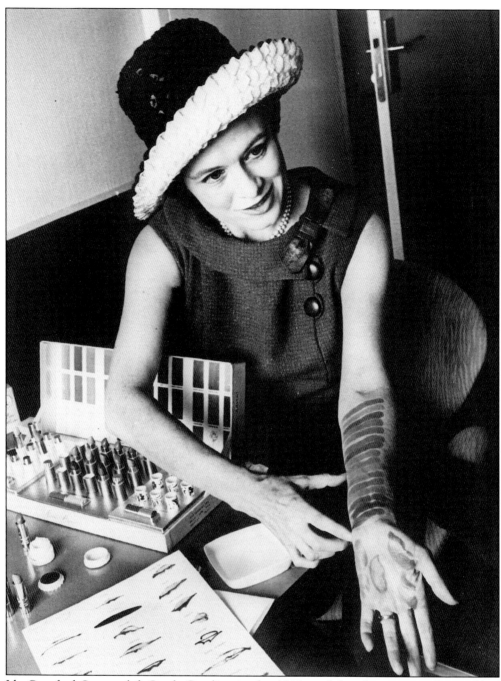

Ida Crawford Stewart left South Carolina in the 1940s and found success in the world of cosmetics. Beginning in 1961, she became a close advisor to Estee Lauder, serving as the entrepreneur's vice president of marketing.

An appreciation of women's roles in history has steadily grown. The United States now celebrates Women's History Month as a recognition of women's achievements.

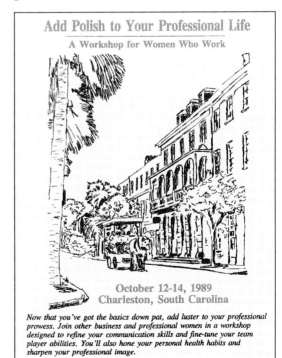

This is the cover of a brochure advertising a workshop in Charleston, South Carolina, for professional working women. It is dated 1989.

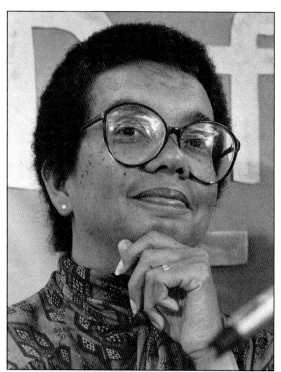

Born in 1939, Marian Wright Edelman grew up in racially segregated South Carolina but has harnessed her experiences and used them to reinforce her commitment as a children's rights advocate. Edelman is founder and president of the Washington, D.C.-based Children's Defense Fund.

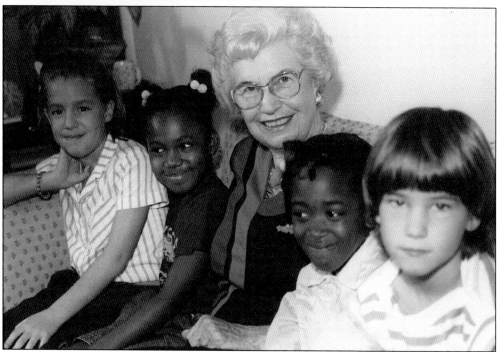

Lillie Herndon of Columbia has made a career out of volunteerism, participating in numerous projects and causes that have benefited South Carolinians. This 1986 photo shows Ms. Herndon, who was then chair of the Richland County Council, with children from A.C. Moore School, as part of her work with the Children's Trust Fund.

118

When Irene Trowell-Harris was promoted to the grade of major-general by order of the U.S. Secretary of the Air Force, she became the first black female general in National Guard history and its highest ranking nurse. A native of Aiken, Trowell-Harris graduated from the School of Nursing in Columbia, South Carolina.

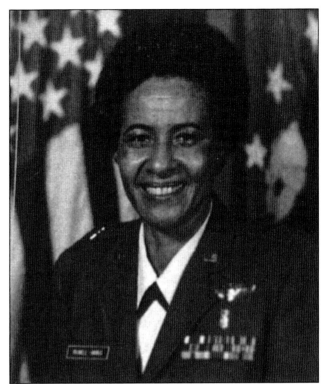

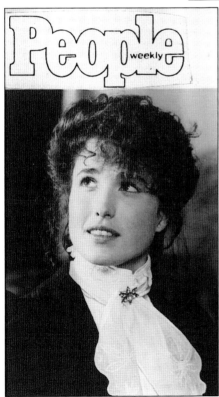

A native of Gaffney, Andie MacDowell has gained fame as an international model and Hollywood actress. She has starred in numerous films, including *Greystoke* and *Sex, Lies, and Videotape*.

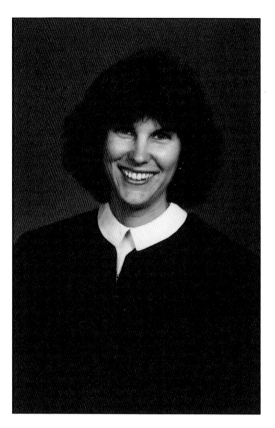

In 1983, Judy C. Bridges became the first female elected to a state judgeship by the South Carolina General Assembly. She serves as judge of the Ninth Judicial Circuit of Charleston and Berkeley Counties.

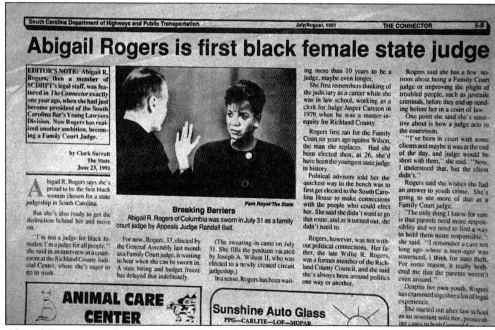

South Carolina Department of Highways and Public Transportation July/August, 1991 THE CONNECTOR 5-B

Abigail Rogers is first black female state judge

EDITOR'S NOTE: Abigail R. Rogers, then a member of SCDHPT's legal staff, was featured in *The Connector* exactly one year ago, when she had just become president of the South Carolina Bar's Young Lawyers Division. Now Rogers has realized another ambition, becoming a Family Court Judge.

by Clark Surratt
The State
June 23, 1991

Abigail R. Rogers says she's proud to be the first black woman chosen for a state judgeship in South Carolina.

But she's also ready to get the distinction behind her and move on.

"I'm not a judge for black females; I'm a judge for all people," she said in an interview in a courtroom at the Richland County Judicial Center, where she's eager to go to work.

Breaking Barriers
Abigail R. Rogers of Columbia was sworn in July 31 as a family court judge by Appeals Judge Randall Bell.

Pam Royal/The State

For now, Rogers, 33, elected by the General Assembly last month as a Family Court judge, is waiting to hear when she can be sworn in. A state hiring and budget freeze has delayed that indefinitely.

(The swearing-in came on July 31. She fills the position vacated by Joseph A. Wilson II, who was elected to a newly created circuit judgeship.)

In a sense, Rogers has been waiting more than 10 years to be a judge, maybe even longer.

She first remembers thinking of the judiciary as a career while she was in law school, working as a clerk for Judge Jasper Cureton in 1979, when he was a master-in-equity for Richland County.

Rogers first ran for the Family Court six years ago against Wilson, the man she replaces. Had she been elected then, at 26, she'd have been the youngest state judge in history.

Political advisers told her the quickest way to the bench was to first get elected to the South Carolina House to make connections with the people who could elect her. She said she didn't want to go that route, and as it turned out, she didn't need to.

Rogers, however, was not without political connections. Her father, the late Willie R. Rogers, was a former member of the Richland County Council, and she said she's always been around politics one way or another.

Rogers said she has a few notions about being a Family Court judge or improving the plight of troubled people, such as juvenile criminals, before they end up standing before her in a court of law.

One point she said she's sensitive about is how a judge acts in the courtroom.

"I've been in court with some clients and maybe it was at the end of the day, and judge would be short with them," she said. "Now, I understood that, but the client didn't."

Rogers said she wishes she had an answer to youth crime. She's going to see more of that as a Family Court judge.

"The only thing I know for sure is that parents need more responsibility and we need to find a way to hold them more responsible," she said. "I remember a case not long ago where a teen-ager was sentenced, I think for auto theft. For some reason, it really bothered me that the parents weren't even around."

Despite her own youth, Rogers has crammed together a lot of legal experience.

She started out after law school as an assistant solicitor, prosecuting cases in both General S...

Abigail Rogers, seen here, is the state's first African-American female judge.

Mary L. Duffie, an advocate for those with life-long disabilities, founded the Babcock Center in 1970 to provide comprehensive community services to people with mental retardation and to offer an alternative to institutional care.

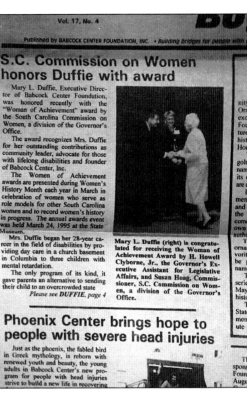

Vol. 17, No. 4

Published by BABCOCK CENTER FOUNDATION, INC. • Building bridges for people with

S.C. Commission on Women honors Duffie with award

Mary L. Duffie, Executive Director of Babcock Center Foundation, was honored recently with the "Woman of Achievement" award by the South Carolina Commission on Women, a division of the Governor's Office.

The award recognizes Mrs. Duffie for her outstanding contributions as community leader, advocate for those with lifelong disabilities and founder of Babcock Center, Inc.

The Women of Achievement awards are presented during Women's History Month each year in March in celebration of women who serve as role models for other South Carolina women and to record women's history in progress. The annual awards event was held March 24, 1995 at the State Museum.

Mrs. Duffie began her 28-year career in the field of disabilities by providing day care in a church basement in Columbia to three children with mental retardation.

The only program of its kind, it gave parents an alternative to sending their child to an overcrowded state

Please see DUFFIE, page 4

Mary L. Duffie (right) is congratulated for receiving the Woman of Achievement Award by H. Howell Clyborne, Jr., the Governor's Executive Assistant for Legislative Affairs, and Susan Hoag, Commissioner, S.C. Commission on Women, a division of the Governor's Office.

Phoenix Center brings hope to people with severe head injuries

Just as the phoenix, the fabled bird in Greek mythology, is reborn with renewed youth and beauty, the young adults in Babcock Center's new program for people with head injuries strive to build a new life in recovering

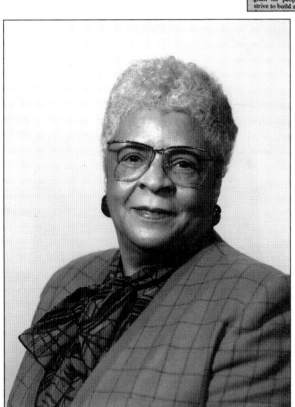

Lancaster native Rubye Johnson has administered several projects for the poor and for minorities, including Project Bus Stop and Project Uplift, which have been implemented across the nation.

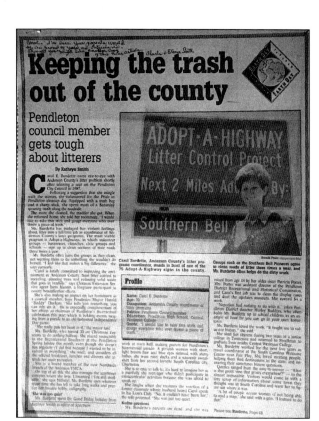

Keeping the trash out of the county

Pendleton council member gets tough about litterers

A native of Pendleton,
Carol Burdette has contributed
significantly to the creation
of public awareness of the
environment in South Carolina.
Among other activities, she has
coordinated a Keep America
Beautiful campaign and has
established a program called
Recycling Days in South Carolina.

As an educator in the Richland County
schools, Joan Assey has been instrumental
in creating innovative programs to
give support to novice teachers and
developing a curriculum that addresses
the issue of gender and racial equity.
She has also served as president of the
South Carolina Network of Women
Administrators in Education.

In 1996, Paula Harper Bethea, a Hilton Head Island resident and a University of South Carolina graduate, became national leader of the United Way of America's governing board. She was the first woman in history to serve in that organization's top post. Bethea has been an active member of many organizations involved with activities relating to women and the family.

A native of Florence, Mariscia Cooper has worked on behalf of the Darlington community as a leader and board member, helping underprivileged children, drug dependent individuals, and students at risk.

Born to deaf parents, Columbia native Pat Flinn has served as a longtime advocate of the handicapped, working as a volunteer at the South Carolina School for the Deaf, Blind, and Multi-handicapped. Flinn presently works as a community relations manager for Southern Bell in South Carolina.

Wenonah George Haire was one of the first Catawba Indians to enter the profession of dentistry. Pictured from left to right are R. Kelly Brown, Wenonah Haire, and Elizabeth Plyer.

Wanda George Warren is a Catawba Indian, a lawyer, and tribal leader who has directed the economical development of the Catawba Indian Nation in the 1990s, after its financial settlement with the U.S. government.

Upon her retirement in 1994, Louise Ravenel served as executive director of the South Carolina Protection and Advocacy System. In 1977, she helped establish For the Handicapped, Inc. During the first years of its operation, the system had a budget of approximately $50,000 and only four employees. By the time of Ravenel's retirement in 1994, the organization had 25 employees and a budget of close to $1.2 million.

Dr. Nora K. Bell has used her pen to make an impact on women at the community, state, and national levels. Much of her work has centered on women's issues, including aging, HIV, and AIDS, in the clinical setting of medicine.

Claudia Brinson has achieved recognition as a senior writer with *The State* newspaper, choosing to emphasize women's issues and concerns so that women are not portrayed in stereotypical ways. Many of her articles have had a powerful impact on women in South Carolina.

As president and chief executive officer of Springs Industry, Crandall Close Bowles is one of the most influential businesswomen in America.

As a psychologist and geriatric specialist, Charlotte Walker has worked tirelessly for the welfare of South Carolina's deaf citizens. Ms. Walker established South Carolina's first mental health program for the deaf shortly after she began working at the Greenville County Mental Health Center in 1972.

Two women who have played a prominent role in preserving the environment are Anne Springs Close (above) and Melody Sirianni (right). Ms. Close serves as chairman of the Close Foundation of Lancaster and was the chair of the National Recreation and Parks Service. She has also worked to conserve natural resources and provide South Carolina citizens with recreational and health resources. Ms. Sirianni has served as a board member of the environmental group CLEAN and has worked closely with the Citizens Clearinghouse on Hazardous Waste, a national environmental organization formed after the Love Canal catastrophe.